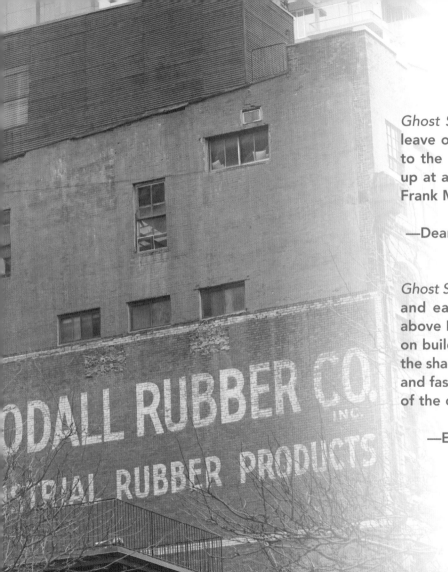

Ghost Signs feeds the yearning all New Yorkers share to leave our mark on this ever-changing metropolis, a shout to the future that we were here. If you've ever squinted up at a fading message from the past, pick up this book. Frank Mastropolo has solved their mysteries for us.

—Dean Karayanis, *The History Author Show*, iHeart Radio

Ghost Signs is a thrilling visual tour of the iconic nineteenth- and early-twentieth-century signs hiding in plain sight above New York's doorways, underfoot on sidewalks, and on building facades. Mastropolo brings these signs out of the shadows and provides historical context that will charm and fascinate anyone interested in peeling back the layers of the contemporary city.

—Esther Crain, author of *The Gilded Age in New York, 1870–1910* and founder of Ephemeral New York

GHOST SIGNS

CLUES TO DOWNTOWN NEW YORK'S PAST

BY FRANK MASTROPOLO

SCHIFFER
PUBLISHING

4880 Lower Valley Road • Atglen, PA 19310

Other Schiffer Books on Related Subjects:

Brooklyn's Sweet Ruin: Relics and Stories of the Domino Sugar Refinery, Paul Raphaelson, ISBN 978-0-7643-5412-0

Door Jams: Amazing Doors of New York City, Allan Markman, ISBN 978-0-7643-4491-6

All color photography © Frank Mastropolo

Type set in Nexa/Avenir LT STD

ISBN: 978-0-7643-5831-9
Printed in China

Published by Schiffer Publishing, Ltd.
4880 Lower Valley Road
Atglen, PA 19310
Phone: (610) 593-1777; Fax: (610) 593-2002
E-mail: Info@schifferbooks.com
Web: www.schifferbooks.com

For our complete selection of fine books on this and related subjects, please visit our website at www.schifferbooks.com. You may also write for a free catalog.

Schiffer Publishing's titles are available at special discounts for bulk purchases for sales promotions or premiums. Special editions, including personalized covers, corporate imprints, and excerpts, can be created in large quantities for special needs. For more information, contact the publisher.

We are always looking for people to write books on new and related subjects. If you have an idea for a book, please contact us at proposals@schifferbooks.com.

TO MY WIFE, BEVERLY,
WHOSE EAGLE EYE SPOTTED MANY OF THESE SIGNS.

4

504–506 Broome Street, 1935. *Courtesy of the Miriam and Ira D. Wallach Division of Art, Prints and Photographs: Photography Collection, New York Public Library Digital Collections*

CONTENTS

INTRODUCTION

Downtown Manhattan is unlike any other part of New York City. On one block you can buy exotic vegetables you would find in a Szechuan marketplace. Around the corner, barkers compete to lure you into a string of Italian restaurants. Outside City Hall, street dancers recruit tourists to join in their routines. Generation Y hipsters listen to K-pop at Avenue C cafés.

Streets follow centuries-old horse trails and wind unexpectedly. This is where *Seinfeld*'s Cosmo Kramer said, "I'm on First and First. How can the same street intersect with itself? I must be at the nexus of the universe!" ("The Maid," *Seinfeld*, 1998).

Although it feels like a new phenomenon, there has always been a frenzy of development downtown. Once it was skyscrapers. Now megatowers and supertalls replace older buildings. Demolition and expansion change a neighborhood's atmosphere and determine who can afford to live there. Overnight, rent increases shutter businesses you thought would always exist.

But there are clues to the stores where we shopped; our schools and places of worship; our jobs and vanished commercial districts; and the places we ate, danced, and even bathed together. The clues are hidden in *ghost signs*: relics that live on long after their businesses and products have vanished or moved on.

Dey Street between West and Washington Streets, 1936. *Courtesy of the Miriam and Ira D. Wallach Division of Art, Prints and Photographs: Photography Collection, New York Public Library Digital Collections*

556 Broome Street

THE WALLDOGS

Long before internet pop-ups and targeted social media ads, signs were painted on the sides of buildings to promote a company's products and services.

Most of the faded ads we see today were painted from the early 1900s to the 1960s. The hardy craftsmen who painted the signs called themselves "walldogs" because they worked like dogs.

In the early twentieth century, walldogs worked long hours tethered to a wall high above the ground, a brush and bucket of paint in their hands. The men had to be part artist, part acrobat, and part chemist.

Walldogs mixed their own paint, a combination of chemicals, color pigments, and a base of white lead paint. Lead poisoning was an occupational hazard. Years of exposure left the painters with skin, brain, and nervous-system damage.

Wind and weather have faded the colors of the ads, but the leaded white paint that leached into the brick helps the signs survive. Like apparitions, the signs are haunting reminders of the past. They may even be the ghosts of the walldogs.

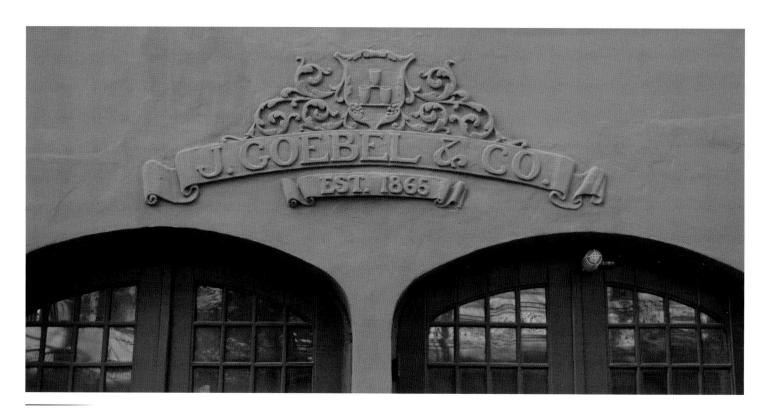

95 Bedford Street

Ghost signs are not just painted on walls. Julius Goebel was a German immigrant who imported and sold clay crucibles, which were used in glass manufacturing because of their resistance to high heat. In 1927, the company moved to a former stable in Greenwich Village, where it remained for decades. A molded insignia with the company's name and a crest with three stacked crucibles were installed above the stable doors.

Some ghost signs are painted on wood.

291 Church Street

Others are manufactured from steel.

125 Rivington Street

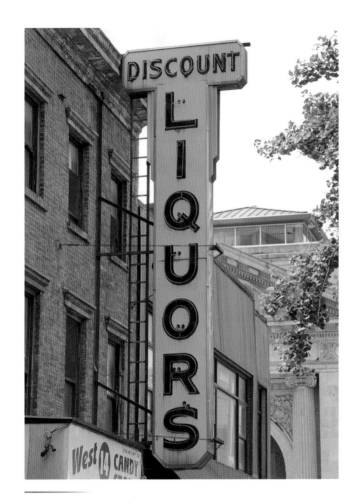

256 West Fourteenth Street

The invention of the lightbulb and later neon, introduced in the US in 1923, changed signage forever. After WWII, plastic became an inexpensive option and helped spell the end of what are considered ghost signs today.

There are many factors that make ghost signs hard to spot.

Sometimes signs are obscured by scaffolding.

12

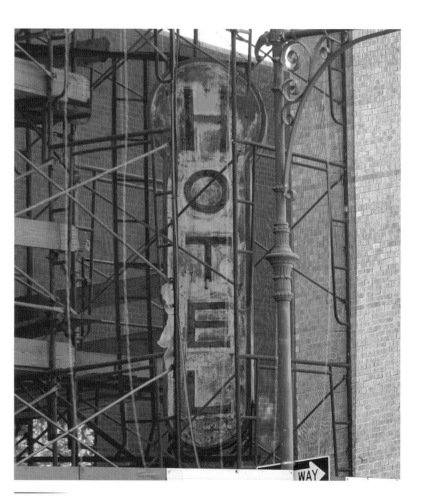

150 Barrow Street

New ads cover the old.

60 Grand Street

Graffiti takes its toll.

275 Canal Street

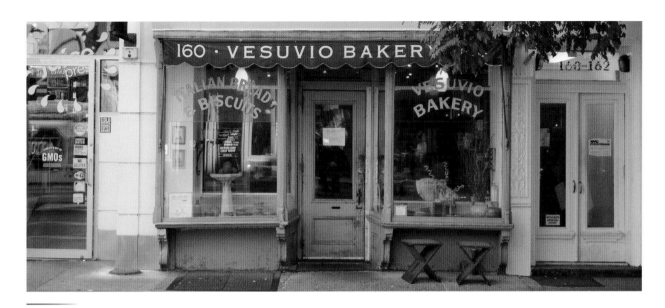

160 Prince Street

Vesuvio Bakery is a ghost sign hiding in plain sight. The SoHo icon was operated for decades by Anthony Dapolito, whose parents started the business in 1920. As a child, Dapolito delivered the bakery's Italian bread and biscuits on a horse-drawn wagon. Vesuvio's lime-green facade endures, but the business has operated as Birdbath Bakery since 2009. The only clue to the new owner is a small sign on the door.

"It's an heirloom, it's a treasure, it means the world," Birdbath owner Maury Rubin told *New York* magazine in 2009.

"That I have a chance to have my bakery be in it is a gift" (Patronite and Raisfeld 2009).

The city's Landmarks Preservation Commission doesn't protect ghost signs. "The commission protects architectural features and the commission does not consider the painted signs a significant feature," a spokeswoman told the *New York Times* (Berger 2005). The commission does, however, encourage building owners to maintain the signs if possible.

All this has made ghost sign hunters urban archeologists, searching for hieroglyphics to tell them about the everyday life of generations past. Will you take the time to unearth them?

There is constant demand for our attention from traffic, store displays, and smartphones. But there is some hope. Ghost sign fans now share their discoveries on social media. Guided tours of faded ads are conducted in many cities. Communities and corporations have commissioned a new generation of walldogs to restore ghost signs in their towns. But the most fun is discovering a sign you've walked past a hundred times.

16

55 Ludlow Street

Sometimes you just have to look up.

530 Canal Street

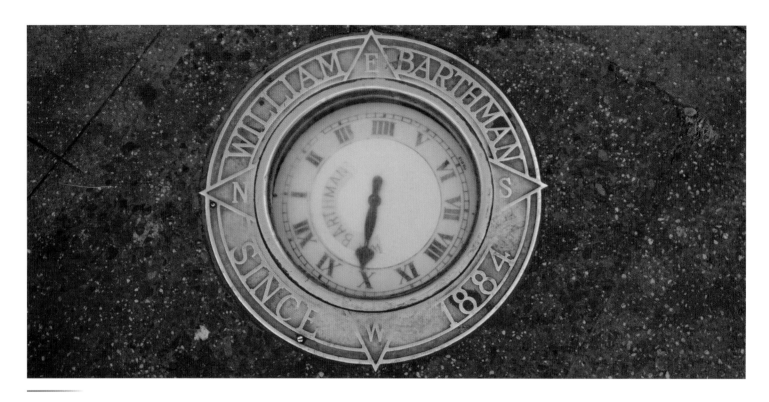

174 Broadway

And down. Millions of people have walked over this clock in the sidewalk since it was installed on the corner of Broadway and Maiden Lane in 1899, when this was the city's **Jewelry District**. How many noticed it?

The unusual sidewalk clock was the brainchild of jeweler William Barthman, who hoped to lure customers into his store. The watch and jewelry store moved from its corner location in 2006 but continues to maintain the clock.

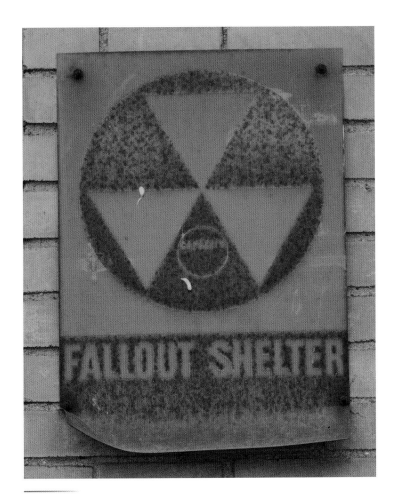

Businesses are not the only sources of ghost signs. New York City has removed many of its 1960s-era fallout shelter signs from public schools and encourages businesses to do the same. The city hoped to avoid confusion because many of the shelters are no longer functional.

145–147 East Broadway

THE NEIGHBORHOODS

Downtown New York, from Fourteenth Street to Manhattan's southernmost point, is a treasure trove of ghost signs. Neighborhood boundaries are not officially designated by the city, so their dividing lines differ according to the source.

Many of the oldest buildings in Manhattan were built in what became the **Financial District**, which extends north to Chambers Street. Its northern section, which includes City Hall and other government buildings, is called **Civic Center**.

It is no coincidence that commerce is king in Lower Manhattan. In the early 1600s, Dutch settlers built a wall for protection that cut off the southern end from the rest of Manhattan. Traders gathered along the wall to buy and sell shares and bonds. The wall was dismantled in 1699, but the name stuck: Wall Street.

Over time, residential areas were pushed northward as businesses expanded. Fishing boats returned from the Atlantic Ocean in the early 1800s and unloaded their catch at East River piers. The **Fulton Fish Market** opened in 1822 along Fulton and South Streets.

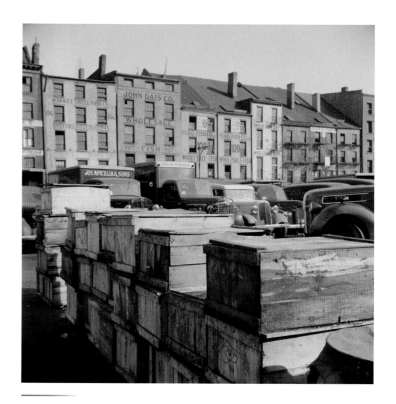

Boxes of fish caught off the New England coast waiting to be shipped to retailers and wholesalers, 1943. *Courtesy of the Farm Security Administration, Office of War Information Photograph Collection, Library of Congress, LC-DIG-fsa-8d28575*

225–227 Front Street

By 1910, the area became one of the busiest wholesale fish markets on the East Coast. The Fulton Fish Market moved to the Bronx in 2005. The South Street Seaport, with its renovated early-nineteenth-century buildings and restored sailing ships, has become a popular tourist destination.

To the north is **Tribeca**, a portmanteau, or blend of words, that means "the triangle below Canal Street." The Tribeca neighborhood originally resembled a triangle on the map; it was bounded by Lispenard, Church, and Canal Streets, and Broadway. Today Tribeca extends from the Hudson River to Broadway and from Vesey Street to Canal Street.

Tribeca was farmland in 1705, when it was included in 215 acres given to Trinity Church by Queen Anne of England. In the early 1800s Tribeca became a swanky residential neighborhood, but that changed by the mid-nineteenth century as Hudson River commerce expanded.

428–432 Greenwich Street

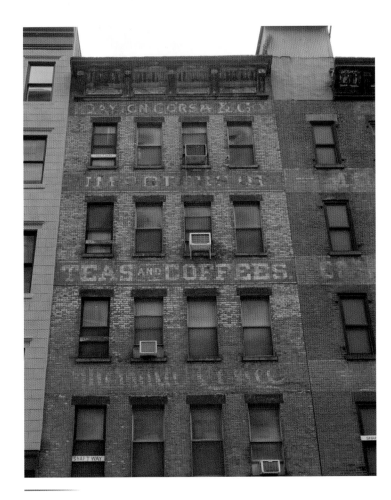

17 Hubert Street

Merchants established a central marketplace near Broadway and Chambers Street. This made Tribeca an undesirable place for the wealthy to live, so they moved to the quieter climes of Greenwich Village and Chelsea. Their homes were replaced by huge loft buildings used as factories and warehouses. Ships docked at Hudson River piers unloaded their freight and stored it here for delivery or processing.

Tribeca was home to coffee roasters and importers at the turn of the twentieth century. Coffee and tea importer Dayton Corsa was established on Hubert Street in 1915, where it remained until the early 1930s.

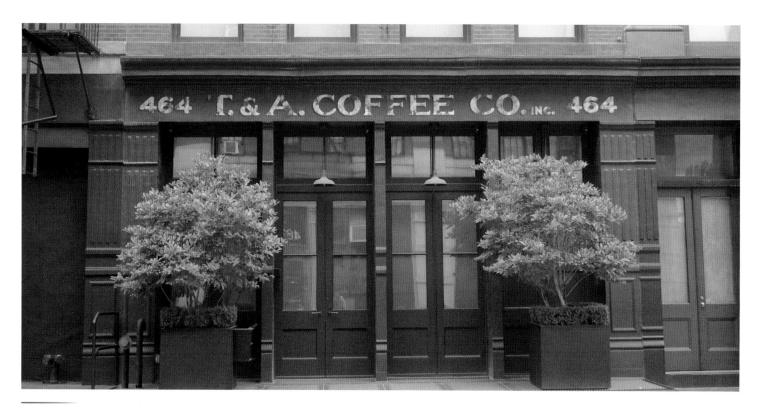

464 Greenwich Street

A few blocks north, the Turkish & Arabian Coffee Co. roasted coffee beans in this 1892 building. Its T.&A. Coffee signage remains.

Today, Tribeca's spacious lofts have become some of the most expensive residences in New York.

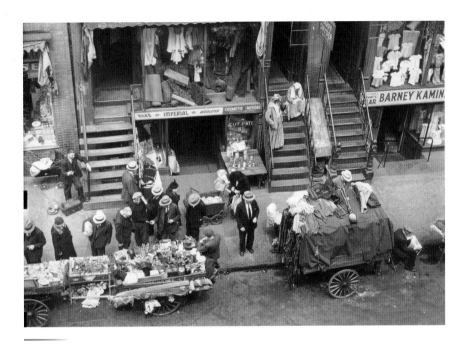

85 Hester Street between Allen and Orchard Streets, 1938. *Courtesy of the Miriam and Ira D. Wallach Division of Art, Prints and Photographs: Photography Collection, New York Public Library Digital Collections*

The character of the **Lower East Side** was defined by the wave of immigrants in the nineteenth and early twentieth centuries. German immigrants established a Little Germany here in the mid-nineteenth century. Succeeding groups of Irish, Italian, and eastern European Jewish immigrants crowded into tenements.

The Lower East Side runs from Canal Street to Houston Street and from the East River to the Bowery. Its commercial artery was Orchard Street, where Jewish immigrants parlayed sidewalk pushcarts into successful clothing and fabric stores.

Polish immigrant Sam Goldstein opened Sam's Knitwear in 1965, at a time when discount clothing stores flourished on Orchard Street. Sam's faded metal ghost sign hangs above the entrance a few steps down from the sidewalk. "The whole Lower East Side has changed; people have changed," Goldstein told *My Small Story* in 2011. "Before, we had young and old, middle-aged. Today you have mostly young people, young styles. Everything has changed" (Batchelor 2011).

Today the Lower East Side's discount clothing, luggage, and leather shops have largely been replaced by bars, art galleries, cafés, and luxury hotels.

In the nineteenth century, the area that is now Chinatown and Little Italy was called **Five Points**, the gang-ridden slums described in Herbert Asbury's book *The Gangs of New York: An Informal History of the New York Underworld* (Asbury 1989). Five Points got its name from the juncture of four downtown streets, which formed five points, or corners, at their intersection.

Chinatown extends from Chambers Street to Delancey Street and East Broadway to Broadway. A large wave of Chinese immigrants arrived from the West Coast in the nineteenth century, after their jobs as miners and rail workers disappeared. White workers denied the Chinese the opportunity to work in other fields, so they came east and settled in Five Points.

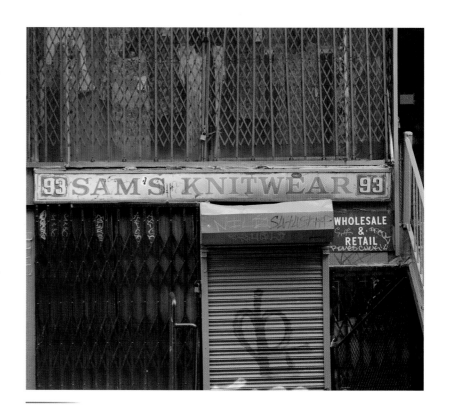

93 Orchard Street

Chinatown grocery store, 1942. *Courtesy of the Farm Security Administration, Office of War Information Photograph Collection, Library of Congress*

Opportunities were not much better in New York, but the Chinese created fraternal and social services organizations to support each other. The Chinese American population boomed after the 1965 Immigration Act reversed decades of exclusionary laws. Today New York has the largest Chinese population of any city outside Asia.

Chinatown is unique as a neighborhood that has maintained its culture. Its streets are lined with stalls selling clothing, bags, and toys. Outdoor fish shops, vegetable markets, herbal pharmacies, restaurants, and food carts vie with pedestrians for space.

Italians came to America to escape the poverty and unemployment of the Old World. Italians largely self-segregated in **Little Italy** by their hometowns. Sicilians lived on Elizabeth Street, Neapolitans on Mulberry Street, and northern Italians on Bleecker Street.

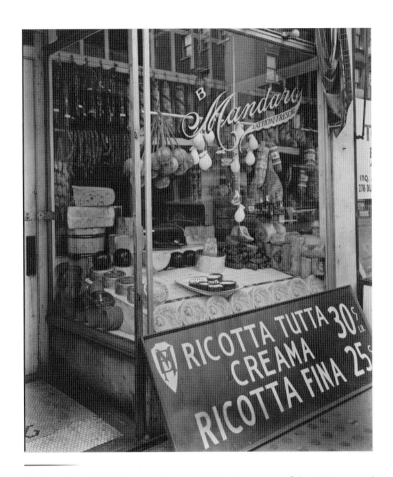

B. Mandaro, 276 Bleecker Street, 1937. *Courtesy of the Miriam and Ira D. Wallach Division of Art, Prints and Photographs: Photography Collection, the New York Public Library*

In the 1920s, Little Italy stretched from Canal Street to Houston Street and the Bowery to Broadway. After WWII, second-generation Italian Americans left Little Italy for New York's outer boroughs, Long Island, and New Jersey. Chinatown expanded as a result, and today Little Italy is essentially Mulberry Street from Canal Street to Broome Street.

While tourists enjoy the souvenir shops and seasonal feasts, many restaurants and specialty shops that have sold Italian delicacies for generations have survived.

SoHo, which means "south of Houston Street," extends from Canal Street to Houston Street and from the Bowery to the Hudson River. By the mid-1800s, retailers that included Tiffany & Co. and Lord & Taylor made lower Broadway a popular shopping destination. Theaters made SoHo the city's entertainment center.

In the mid-nineteenth century, cast-iron industrial buildings with high ceilings were built in SoHo to house textile factories and clothing outlets. But by the end of WWII, most of the textile industry had left Manhattan for the South. Many of SoHo's buildings were abandoned.

In the late 1960s, artists began to move into the large loft spaces left behind. Today many of the artists have been driven out by high rents, displaced by trendy shops and restaurants.

The **East Village** was considered part of the Lower East Side until the mid-1960s, when it was named to borrow some of Greenwich Village's appeal. Originally the farmland of Peter Stuyvesant, the last Dutch director general of New Netherland, the neighborhood runs from Houston Street to Fourteenth Street and the East River to Broadway.

The East Village has long been home to political dissidents, labor activists, musicians, artists, and working-class folks in search of affordable places to live and start a business.

Germans, Italians, Asians, and eastern European Jews all have had an influence on its culture. In the mid-1800s, the Lower East Side was home to 60,000 Germans and was known as *Kleindeutschland*, or Little Germany.

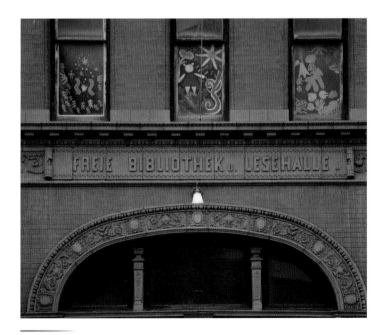

135 Second Avenue

German-language newspaper publishers and philanthropists Anna and Oswald Ottendorfer hoped to educate German immigrants by building the Freie Bibliothek und Lesehalle (Free Library and Reading Room), the first public library in New York City. Half its books were in German and half in English.

Yiddish theater thrived in the East Village at the beginning of the twentieth century. The stretch of playhouses on Second Avenue was called the Jewish Rialto.

By the twenty-first century, gentrification had displaced many of the East Village's longtime residents. Young professionals flocked to new and renovated apartments.

The inclusive atmosphere of **Greenwich Village** has made it a bohemian enclave for more than a century. Artists enjoyed the freedom to explore new forms. Jazz, folk, and rock musicians found enthusiastic audiences here in the 1950s and '60s. Many of the world's best-known playwrights, poets, and artists got their start in Village coffee houses, nightclubs, galleries, and theaters.

The buzz of sidewalk cafés and street musicians today belies the fact that in the eighteenth century, Greenwich Village was a sleepy summer retreat for downtown businessmen and their families. Much of New York City was concentrated south of today's Canal Street; Greenwich Village was largely farms and estates.

Greenwich Village runs from Houston Street to Fourteenth Street and Broadway to the Hudson River. Its environs west of Seventh Avenue South include the **West Village** and the **Meatpacking District**.

29

Washington Street and Loew Avenue, 1936. *Courtesy of the Miriam and Ira D. Wallach Division of Art, Prints and Photographs: Photography Collection, New York Public Library Digital Collections*

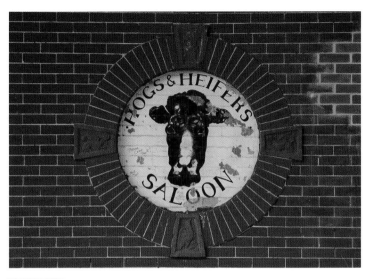

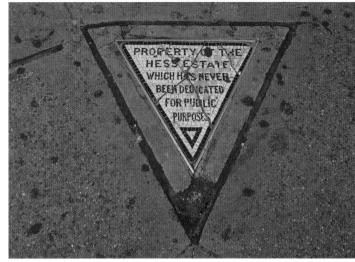

859 Washington Street

110 Seventh Avenue South

When Hogs & Heifers Saloon opened in 1992, the Meatpacking District was a high-crime area of slaughterhouses and packing plants. Bikers and market workers were its clientele. As high-end boutiques moved in, the area became a tourist destination. A rent increase forced Hogs & Heifers to close in 2015.

Almost as much fun as finding a ghost sign is learning the story behind it. This triangular plaque is embedded in the sidewalk at Christopher Street and Seventh Avenue South in Greenwich Village. What does it mean?

On the site had been a five-story building called the Voorhis that was owned by David Hess. The Voorhis was seized by the city through eminent domain and demolished in the late 1910s to build the IRT subway line. Years later the Hess estate realized that the city's survey missed this small triangle of land. The city asked the family to donate the property. They refused and in 1922 installed the sign as a protest. The family finally sold the tiny plot in 1938 to the corner's Village Cigars for $1,000.

I hope that this collection of downtown New York ghost signs will inspire you to find your own where you live. Happy hunting!

CHAPTER ONE: SHOPPING

S. BECKENSTEIN

Samuel Beckenstein was a Polish immigrant who sold odd lots of fabric he bought from clothing manufacturers. After starting as a pushcart merchant, he established Beckenstein's Men's Fabric in 1919.

Beckenstein created a business that catered to men who could not afford a new suit when the pants wore out. He began to buy leftover fabric from men's suits manufacturers and carefully cataloged the material by manufacturer. The entrepreneur then contacted dry cleaners around the country. He offered to make pants that would exactly match the jackets of men's suits. By the 1930s, Beckenstein advertised his business as the "World's Largest Pants Matching House."

Pants matching was a success, with 400 to 500 pairs a week shipped. The 1932 song "Sam, You Made the Pants Too Long," cowritten by Milton Berle, was purportedly about Beckenstein. Barbra Streisand released a version of the tune in 1970.

In 1945 the company moved to a new home, the former New York Telephone Co. building at 130 Orchard Street. Beckenstein completely covered the second and third floors with signage for his business, announcing the "World's Largest Values & Savings" and a "Special Remnant Dep't." Two large "Entrance" arrows point to the doors.

In time, fabric businesses departed Orchard Street, replaced by leather and hat shops. Beckenstein was one of the last holdouts when it moved uptown in 1999.

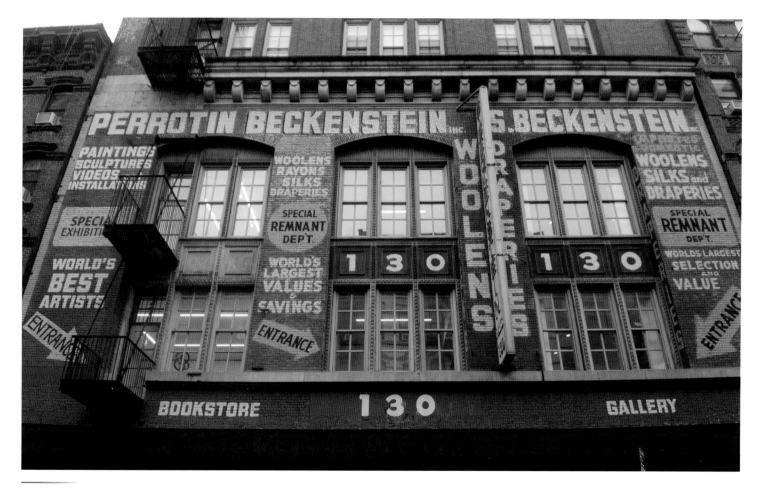

130 Orchard Street

DE ROBERTIS PASTRY SHOPPE

De Robertis Pastry Shoppe closed in 2014 after more than a century serving Italian coffee, pastries, cookies, and ices. Four generations of the De Robertis family worked at the pasticceria since it opened in 1904. John De Robertis, whose grandfather Paolo started the business, described the store's early days in *Bedford+Bowery* (http://bedfordandbowery. com): "They made pignoli, the seeded cookies, and they made coffee, cappuccino, and as refrigeration came in they started making pastries, cannoli. Then as time went by they started making lemon ice. They catered to the Italians because that's what everybody around here was used to.

"The heyday of the store's popularity was in the '60s. As soon as church was over, whatever mass people went to, they all piled in here. We were packed. They came in for coffee and cannoli, sfogliatelle, whatever."

De Robertis said that the neon sign, which spans the width of the building, was probably erected in the 1940s. "We never really had people come over to our apartment because we were always working," explained De Robertis. "My father said, 'This is like my living room. I can't have people over my house because I'm always here, so this is my living room.' And people like that. It's that love that you can't get from a chain store" (Mastropolo 2014).

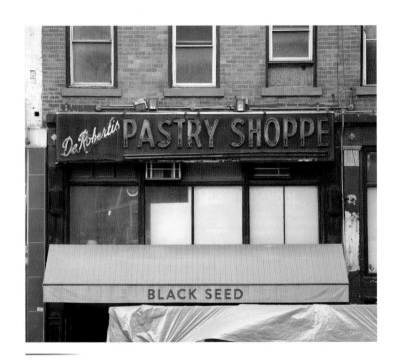

176 First Avenue

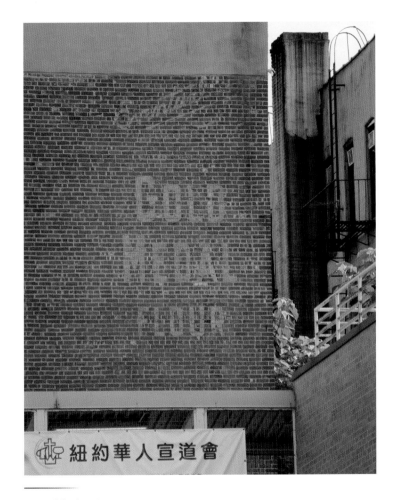

164 Eldridge Street

GOLD MEDAL FLOUR

Gold Medal Flour was originally named Washburn Crosby's Superlative Flour. "In 1880, our very first entry into an international millers' competition won a gold medal," reads the Gold Medal website. "So, we thought that was a great reason to change our name."

The faded sign, at least fifty years old, is visible from Delancey Street. The script above "Gold Medal Flour" reads "Eventually." It is a shortened version of the flour's old slogan, "Eventually . . . Why Not Now?"

G. LA ROSA & SON BREAD CO.

Successive tenants have preserved the signage of G. La Rosa & Son Bread Co. The SoHo building is a renovated 1850s New York City firehouse. Giacchino La Rosa operated the bakery until the 1950s, when he retired and sold the business to a family member.

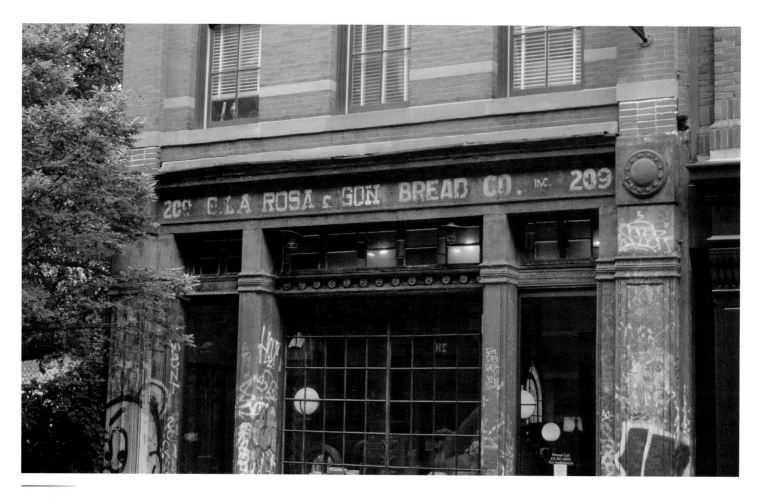

209 Elizabeth Street

HYGRADE'S ALL-BEEF FRANKFURTERS

Sir Winston Churchill Square is a garden and sitting area at the juncture of Downing Street and Sixth Avenue. The site was purchased by the city's Parks Department in 1943. The square, designed by George Vellonakis, was rebuilt in 1998–1999, adding a garden, an armillary sphere, and a decorative fence. The square is named in honor of the British prime minister who guided the UK through WWII.

Overlooking the square is a ghost sign advertising Hygrade's frankfurters, a brand that dates to 1914. Hygrade was founded by Samuel Slotkin, a Russian immigrant who was one of the first to produce packaged meats for consumers.

"Mr. Slotkin's first loyalty was always to the quality frankfurter," notes Slotkin's 1965 *New York Times* obituary. "Early in his career he frowned on mixing meats in frankfurters and developed an all-beef frankfurter."

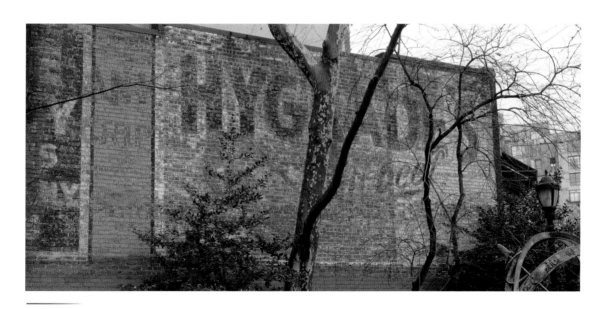

281 Sixth Avenue

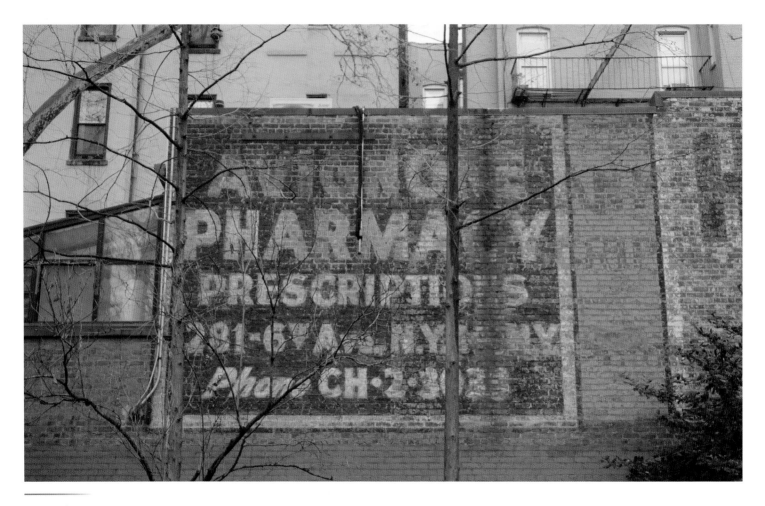

281 Sixth Avenue

AVIGNONE PHARMACY

When Avignone Pharmacy closed in 2015, it was one of the oldest drugstores in New York City. The proudly antichain pharmacy was founded in 1832 as Stock Pharmacy. Italian immigrant Francis Avignone bought the business in 1898 and changed its name to Avignone Pharmacy. Its original location was 59 MacDougal Street, which was demolished when Houston Street was widened.

In 1929 Avignone moved the shop to 281 Sixth Avenue, a building the family erected for the pharmacy. Avignone's son Carlo ran the business from 1956 until it was sold in 1974.

Abe Lerner owned and operated Avignone for thirty years but was forced to close its doors in 2015, when the landlord tripled his rent. "I've spent half my life here," Lerner told *DNAInfo*. "I've known many of these people for thirty years; I've seen a lot of kids grow up. A lot of these people have become friends— they're not just customers, they're friends" (Tcholakian 2015).

The Avignone painted sign shares the wall with the Hygrade's sign overlooking Sir Winston Churchill Square.

TREE-MARK SHOES

"Mental comfort begins in your feet," reads a 1939 newspaper ad for Tree-Mark Shoes. "Complete foot happiness is guaranteed if you wear Tree-Mark Shoes." Tree-Mark Shoes emphasized comfort over style. A 1970 *New York Times* article noted that Tree-Mark specialized in "boots for women with larger than average calves." An in-house custom department manufactured and fitted shoes for abnormal feet.

Tree-Mark, which had three New York locations, occupied the former movie theater for almost thirty years. The parapet along the smooth limestone roofline is engraved with the company's name.

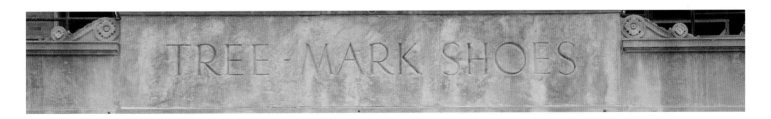

6 Delancey Street

REX COLE

In the 1930s, master salesman Rex Cole was chosen by General Electric to promote its new line of Monitor Top refrigerators, which housed the motor, compressor, and condenser on the top of the cabinet. The Monitor Top was the first electric refrigerator designed for the home market. Cole hired architect Raymond Hood to create spectacular showrooms in New York City to promote General Electric refrigerators.

The modernistic buildings featured 15-foot-high replicas of the Monitor Tops on the roof. Cole, nicknamed "King Cold" as a pun on his product, erected enamel signs through-out the city to promote his dealerships. By 1931, Cole re-portedly had 1,000 employees and $15 million in sales despite the Great Depression. But by 1935, fewer people could afford refrigerators, and Cole filed for bankruptcy. Hood designed at least fifteen showrooms for Cole, but they all have been demolished or drastically modified.

Two of the remaining metal signs survive thanks to building owner Charlotte Storper. Her husband, Sidney, died in 2000, and when Mrs. Storper had the building's facade cleaned in 2001, she made sure the two Rex Cole signs remained.

In 2003, Storper told the *New York Times* that she and her husband bought the building in the 1950s. "We kept it all through the years, through the flower children and the ups and downs of the '60s and '70s," she said. "At one point I said the signs were unsightly, but he said, 'Those signs are a part of history'" (Gray 2003).

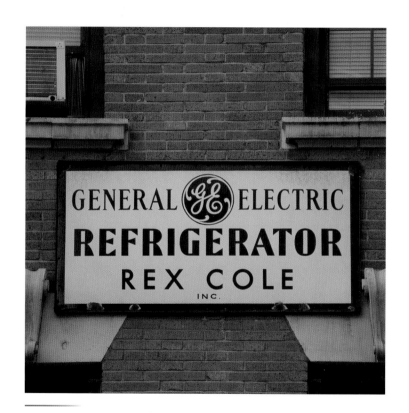

87 Second Avenue

170 First Avenue

P. N. CORSETS

By the 1890s, women's corsets were a hot item, advertised in newspapers and magazines across the US. One of the leading brands was P. N. Practical Front Corsets, manufactured by I. Newman & Sons. The company was founded by Issac Newman in the 1870s. The P. N. purportedly refers to Newman's wife, Pauline.

The marketing feature of P. N. Corsets was its Practical Front, an inner elastic vest that prevented the corset from riding up. "Youth Is Beauty—Youth Is Style," reads a P. N. ad from 1925 that shows two women admiring a flapper's figure. "A touch here and a slight yield there and the style becomes your style."

The lettering of the four-story ad for P. N. Corsets probably dates it to the early 1900s, decades before Madonna made the girdle a fashion statement. Because neighboring 168 First Avenue is set back a few feet, there is just enough wall space to squeeze in the corset ad.

41

WITTY BROTHERS

The Witty family—brothers Spencer, Frederic, Ephraim, and Arthur, and cousin Irving—expanded Polish immigrant Henry Witty's Eldridge Street store into a manufacturing plant employing 400 workers and a chain of six high-end menswear shops. "They used luxurious fabrics, cashmere, Scottish tweeds," Jane Gould, Spencer Witty's daughter, told the *New York Times* (Hevesi 2006).

One fan of Witty Brothers clothing was Edward "Monk" Eastman, a mobster whose Eastman Gang dominated street crime in New York in the early twentieth century. Eastman was gunned down in 1920 by gangsters on Fourteenth Street and Fourth Avenue. Detectives found a Witty Brothers tag with Eastman's name inside his jacket. After the murder, Henry Witty said in the *New York Tribune*, "Monk Eastman, the old time gang leader . . . we have made clothes for him for 19 years."

The Witty Brothers name remains on the facade above the second floor. Nicole Witty, granddaughter of Frederic Witty, said in *Bedford+Bowery* that by 1962, the business "was no longer financially viable due to unionization of workers and production moving to the South. At that point it was sold to Eagle Brothers, which then licensed out the name without regard for quality that the brand had stood for. Think Jewish Brooks Brothers, fine men's clothing with a little extra pizzazz that the gangsters liked" (Mastropolo 2018).

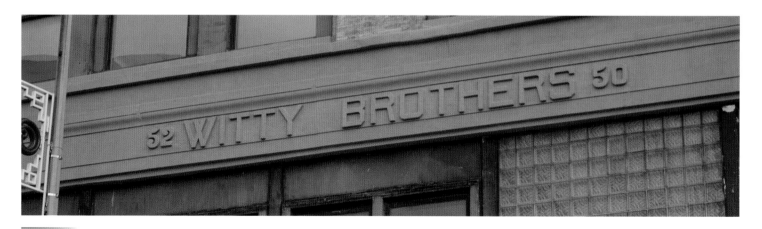

50–52 Eldridge Street

MARTIN ALBERT CUSTOM DECORATORS

In 1980, Martin Zeliger and Albert Harary founded Martin Albert Custom Decorators on the Lower East Side. "It used to be on Sundays you couldn't move on that street," said Harary, the company's vice president. "At one point we had a guard at the door; we couldn't let everybody in at one time. Our store was maybe 1,000 square feet. We built a good business."

Its two-story sign, with a bold red arrow pointing to the entrance, was painted a year or two after the store opened. "We're looking at about $300 to paint the sign and considering how they designed the lettering, it was a little rough. I think it was a guy with a scaffold. We didn't have money for sign painters.

"The arrow was there and we had a phone number there. There was a phone number on the sign that was faded. A year or two ago somebody painted over the sign so it wouldn't disappear from the world. But they painted over the phone number! Kind of an amateur restoration."

Martin Albert moved from the neighborhood in 1993. "It was such an interesting area, everything that was going on," said Harary. "These tiny little stores were there for thirty or forty years. That's all gone now. It's a shame" (Mastropolo 2018).

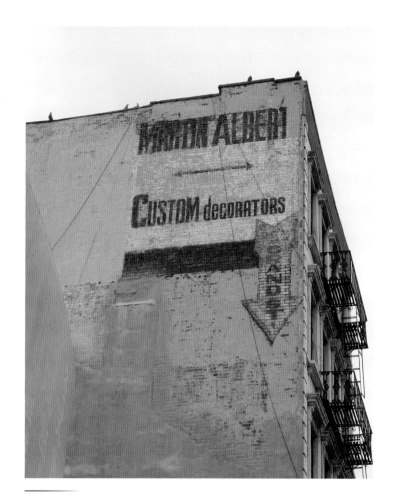

288 Grand Street

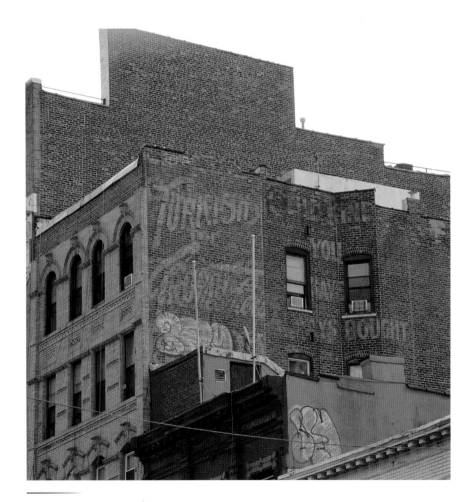

13 Division Street

TURKISH TROPHIES CIGARETTES AND FLETCHER'S CASTORIA

Turkish Trophies cigarettes were produced from 1892 to about 1930. The tobacco ad is hard to decipher because it is painted over an older ad for Fletcher's Castoria, a children's laxative. The word "Trophies" is partially obscured by "Fletcher's." On the right is the rest of the laxative ad: "The Brand You Have Always Bought."

M. SCHAMES & SON PAINTS

Russian immigrant Mendel Schames opened his paint business on the Lower East Side in 1927. When the building next door at 5 Essex Street was demolished in 2010, the work destabilized the shared exterior wall with Schames. The paint dealer moved to Delancey Street but left behind two of the largest and brightest ghost signs in the neighborhood.

The building-wide sign over the entrance displays two Benjamin Moore paint cans. Two stories above is a huge Dutch Boy Paints sign. The style of the Dutch Boy logo dates the sign to the mid-twentieth century.

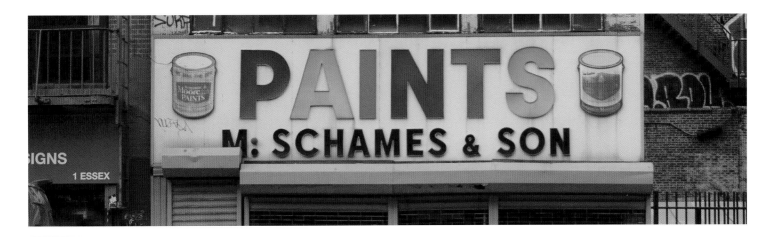

3 Essex Street

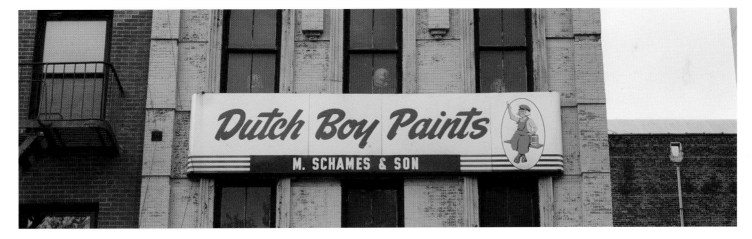

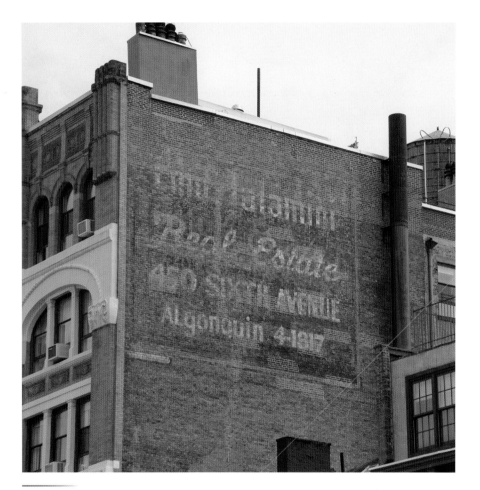

EMIL TALAMINI REAL ESTATE

The two-story-high Emil Talamini Real Estate sign towers over Sixth Avenue in Greenwich Village. Its Algonquin-4 telephone prefix dates it to the 1950s or earlier. Village resident Emil Talamini was a real-estate broker and investor who maintained an office in the building.

450 Sixth Avenue

EDELSTEIN BROS. PAWNBROKERS

Jazz legend Charlie Parker's life was plagued by bouts of depression and heroin addiction. The saxophonist, known as Bird, died in 1955 at age thirty-four. Parker kept a chronology of the last ten years of his life, which was published as *Bird's Diary: The Life of Charlie Parker, 1945–1955* by Ken Vail (Vail 1996). Its last page shows a pawn shop ticket for Parker's King Super 20 alto sax from Edelstein Bros. Pawnbrokers. The ticket is dated Jan. 24, 1955, less than two months before Parker's death.

The Edelstein brothers were Isaac and Max Edelstein, who inherited the shop from their father, Simon Edelstein. The two brothers first worked with their father at the family's shop on First Avenue. They moved to the Fourteenth Street location in 1945, where they remained until 1981.

One of Parker's saxophones was part of an auction of personal items owned by jazz icons held at Lincoln Center in 2005. The saxophone, said to be Parker's main instrument in the 1950s, sold for $225,000.

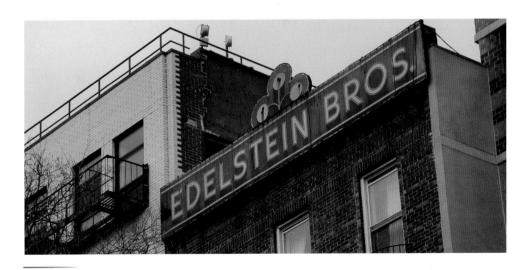

233 East Fourteenth Street

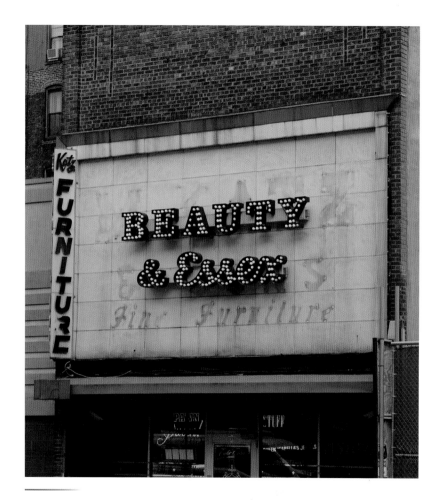

146 Essex Street

M. KATZ & SONS FINE FURNITURE

In the twentieth century, shoppers flocked to the furniture stores along Essex Street and Avenue A for bargain prices. Meilich Katz founded M. Katz Furniture in 1906. The company's website notes that "M. Katz, whose business still bears his name today, began by selling furniture out of a tenement in the Lower East Side of Manhattan and eventually moved his thriving furniture business to a location on Stanton Street, just around the corner from where Katz Furniture stood for over fifty years on Essex Street."

The Beauty & Essex restaurant, lounge, and pawn shop has retained the M. Katz signage with its own.

48

MAX FEINBERG

Orchard Street has welcomed new citizens since the mid-nine-teenth century, when Jewish, Italian, and Irish immigrants arrived from Europe. To serve their needs, Orchard Street became a discount shopping hub where haggling over prices was an art form. Merchants originally sold their merchandise from baskets, then pushcarts. Laws that banned pushcarts in the 1930s encouraged vendors to establish their own stores along the street.

The Lower East Side building that would house Max Feinberg was erected in 1910 as an apartment house. The Shearith Israel Sisterhood later operated a settlement house on the site to provide for Sephardic immigrants. The settlement house moved to Eldridge Street and Max Feinberg purchased the building in 1928.

Feinberg sold ready-to-wear children's clothes from the storefront. The second floor was used for his office, and the third floor for storage. Feinberg erected a building-wide sign with his name between the second and third floors that survives in remarkably good shape.

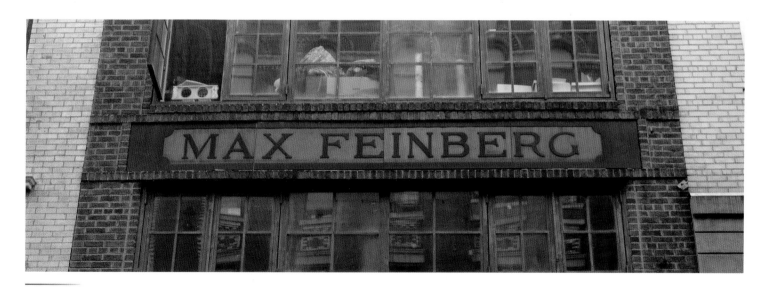

86 Orchard Street

BAKER BRUSH CO.

Baker Brush was a manufacturer and importer of high-quality brushes for artists and contractors. Its ad in *Popular Science* promoted its line of brushes and rollers for house painting: "Brushes by Baker. Better brushes for better painting. A style for every purse and purpose." If you sent a postcard to the company, you would receive a free booklet, "How to Do a Good Paint Job."

Baker Brush was founded by Alfred Baker in 1908 on Fulton Street and moved to Grand Street in 1915, where it remained until 1975. No sign of the company remains on Grand Street, but around the corner on Greene Street is a ghost sign for the Baker Brush receiving entrance.

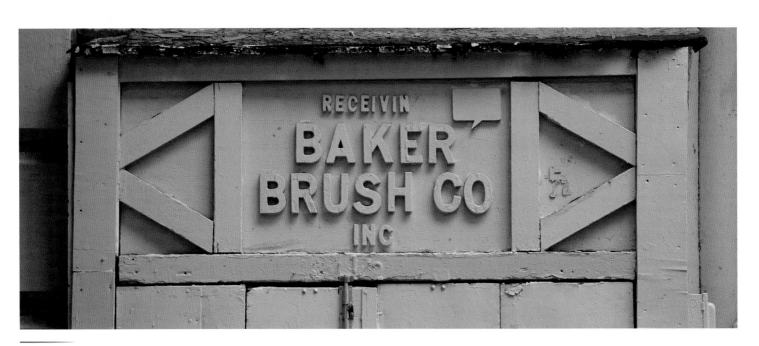

31½ Greene Street

MATERA CANVAS

"If it is canvas you need, Matera Canvas has it: boat covers, tarpaulins, tote bags, awnings, aprons, and items some people wouldn't think of making of canvas," the *New York Times* noted in 1990.

The Matera family worked in the canvas business beginning in the early twentieth century. "Any canvas work that would be needed on a boat, we can make," said Peter Matera, the third generation of his family in the trade. "An Indian reservation in New Mexico wanted a custom teepee" (Brewer 1990).

Matera Canvas moved to 5 Lispenard Street in Tribeca, two blocks from the large square sign, in 1970. The store closed in 1997.

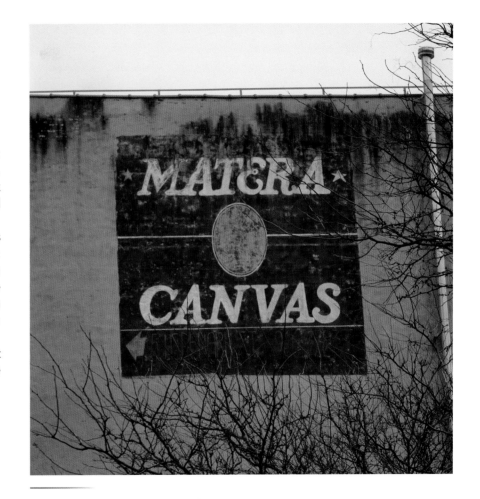

51

4–6 White Street

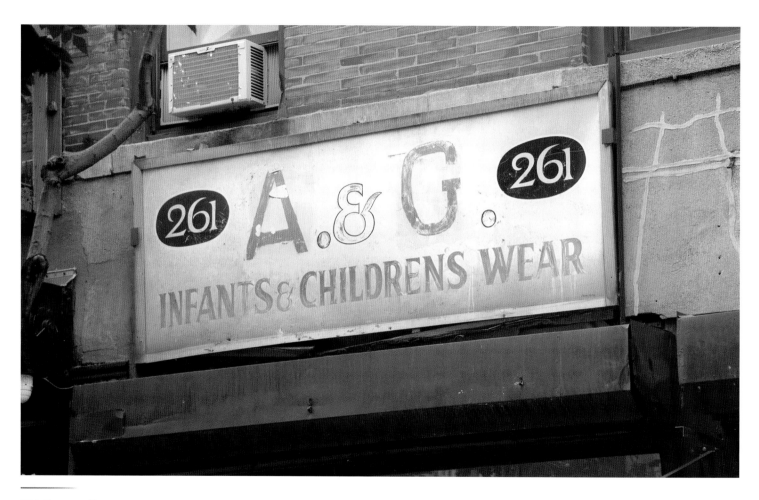

261 Broome Street

A. & G. INFANTS AND CHILDREN'S WEAR

Most of the mom-and-pop clothing stores around Orchard Street are gone, but the A. & G. Infants & Children's Wear sign remains a reminder of the area's retail past. The Denny Gallery was one of the occupants that had retained the sign.

"I was twenty-eight when I opened the gallery, and now I have a family, staff, and artists who depend on the business," owner and curator Elizabeth Denny told *Bedford+Bowery*. "I feel connected to the many generations of young entrepreneurs who have gotten their start on the Lower East Side. Galleries are among the most recent wave, but we have many of the same pressures and concerns—globalization, competition from within and outside of the neighborhood, supporting our families, making it in New York—that clothing dealers and other store owners of past generations had" (Mastropolo 2016).

MARLBORO SHIRTS

Marlboro was a popular sportswear brand in the mid-twentieth century. In the 1940s, film star Ronald Reagan appeared in a series of ads for Marlboro shirts.

Marlboro shirts carried a tag with an image of a clothespin: a guarantee that the fabric was "unconditionally washable."

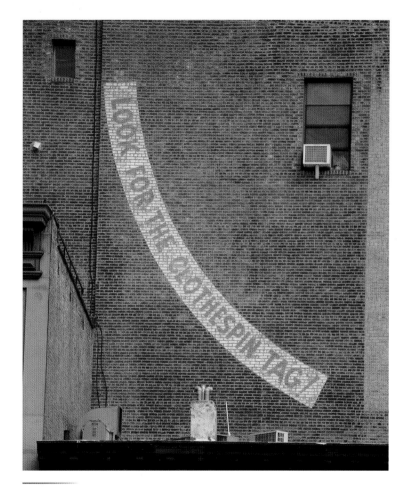

36 White Street

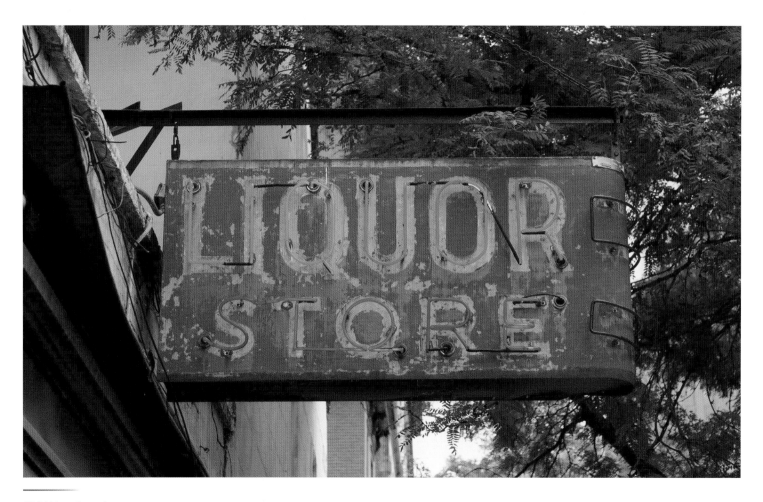

235 West Broadway

HECHT LIQUORS

The retail space of an 1809 two-story house in Tribeca served as a cigar shop and a barber shop in the early twentieth century. In 1941, Leonard Hecht founded Hecht Liquors here. Hecht installed a neon sign that simply reads "Liquor Store."

Hecht Liquors thrived for almost fifty years as the neighborhood became more upscale. In the 1990s the Hecht family, which owned the building, closed the shop. Its new tenant: the Liquor Store Bar, which retained the signage from the liquor store. The bar was open for ten years until it lost its liquor license.

RAGÚ SPAGHETTI SAUCE

In 1937, Giovanni and Assunta Cantisano sold homemade tomato sauce from their front porch in Rochester, New York. In 1946 they opened their first factory to produce Ragú Spaghetti Sauce. By 2014 Ragú was the bestselling brand of pasta sauce in the US.

Bob Middleton of the Mack Sign Co. painted a Ragú ad in Tribeca in the early 1970s. To the left of the jar was Ragú's slogan, "The Sauce Men Ask Their Wives to Buy!" The Ragú sign was painted over in 2018.

11 Sixth Avenue

55

CHAPTER TWO: WORKING

Broome Street, 1942. Courtesy of the Farm Security Administration, *Office of War Information Photograph Collection, Library of Congress, LC-DIG-fsa-8d21963*

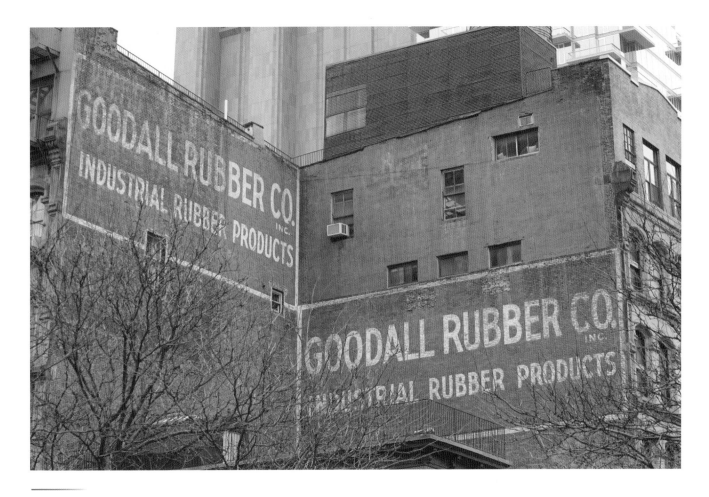

5 White Street

GOODALL RUBBER

Two adjoining signs for Goodall Rubber dominate a corner of Tribeca. Goodall moved to its White Street location in the late 1930s, where it sold rubber hoses, tubing, belts, and protective clothing that included boots, gloves, and aprons.

The company was founded in Philadelphia in 1906 by Howard W. Goodall, William S. Feeny, and Frederick D. Stovell. Goodall remained on White Street until the 1970s.

MARINE ENGINE SPECIALTIES

Marine Engine Specialties moved to SoHo in 1950. Its proximity to the then-bustling Hudson River ports kept its workers busy. Marine Engine manufactured boilers, pumps, heat exchangers, and other equipment for the commercial maritime industry.

Marine Engine was founded and run by Edwin Burke. Burke moved Marine Engine to Clifton, New Jersey, in 1969 and renamed the company MESCO. Burke died in 1971 and the company closed a year later. The building was purchased by artist Claes Oldenburg, who retained the Marine Engine ghost sign.

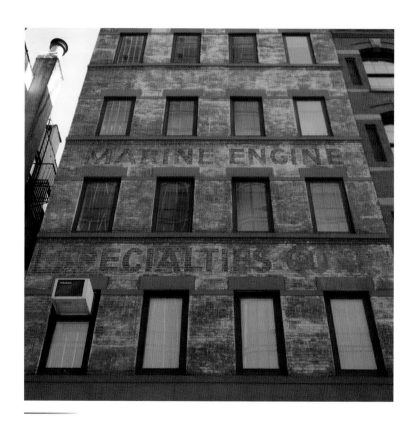

556 Broome Street

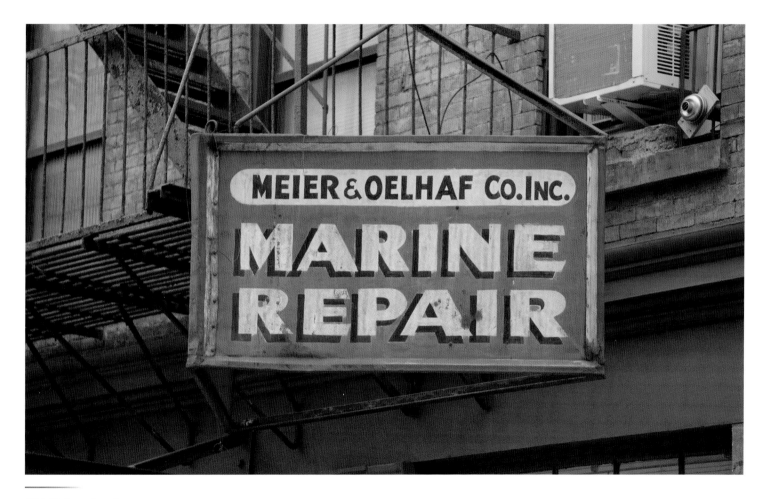

177 Christopher Street

MEIER & OELHAF MARINE REPAIR

North of Marine Engine Specialties along the Hudson River was Meier & Oelhaf, a company that performed, according to a 1909 ad, "ship work of all descriptions." Frank Meier and Carl F. Oelhaf founded the firm in 1905.

Meier & Oelhaf moved to this Greenwich Village location in 1920. Two identical signs remain, although the company left decades ago.

GARVIN MACHINE

In the early twentieth century, the Canal Street area was known as the Machinery District. Factories that manufactured machines used to cut, bore, grind, and shape metal coexisted with dealers of used equipment that served the city's book printers, food canners, and garment makers.

Garvin Machine was founded in the late 1800s as E. E. Garvin & Co. A series of fires forced them to move their factory to this Varick Street location in 1897. Garvin had a six-story sign painted on the side of the building, where they would remain until the mid-1920s.

137 Varick Street

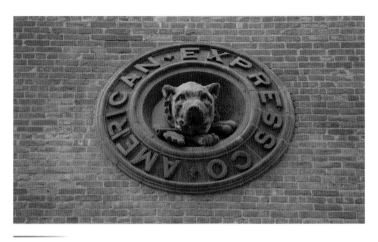

4–8 Hubert Street

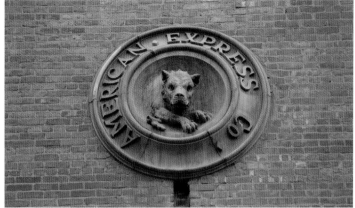

55 Laight Street

AMERICAN EXPRESS

American Express was founded in 1850 in Albany, New York, as an express delivery company, a time when horse-drawn carriages were used for local deliveries. Its first headquarters was at 10 Wall Street. In 1866 American Express built stables on Hubert and Collister Streets to house the horses. A terra-cotta watchdog was erected high on its Hubert Street facade.

Before the Centurion became synonymous with American Express, the company's logo was a watchdog. "The American Express watchdog logo first appeared in the late 1850s on delivery receipts and promotional materials," said Ira Galtman, director of corporate archives. "The dog represented safety and security, which were critical to the success of our express business. We used different versions of the watchdog logo until the end of the nineteenth century" (Mastropolo 2018).

Architect Edward Hale Kendall designed the 1898–1899 expansion of the building to Laight Street, which featured a different watchdog logo.

By the time the Parcel Post system was established in 1913, American Express had already begun its transition to a financial services company. Horse-drawn carriages became extinct, and American Express moved from the building in 1918.

MANN REFRIGERATION

Mann Refrigeration was located in a cast-iron building in the East Village, one of a string of landmarked structures that stretch south on Lafayette Street from Astor Place. Like the American Express stables, the building was designed by Edward Hale Kendall and was built in 1870 for men's clothier Alfred Benjamin & Co.

Mann Refrigeration was run by Moe Mann from a variety of addresses in the area beginning in 1941. The company operated here from 1952 to 1972. Its legacy is the brass clock that bears the company name.

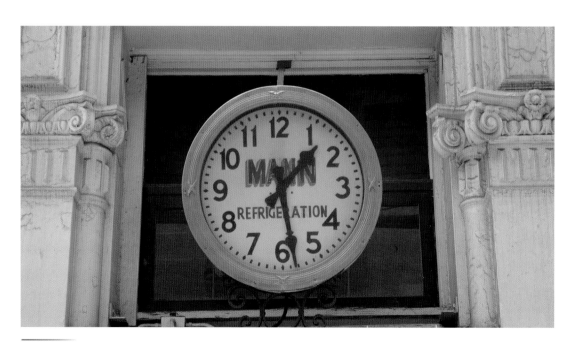

436–440 Lafayette Street

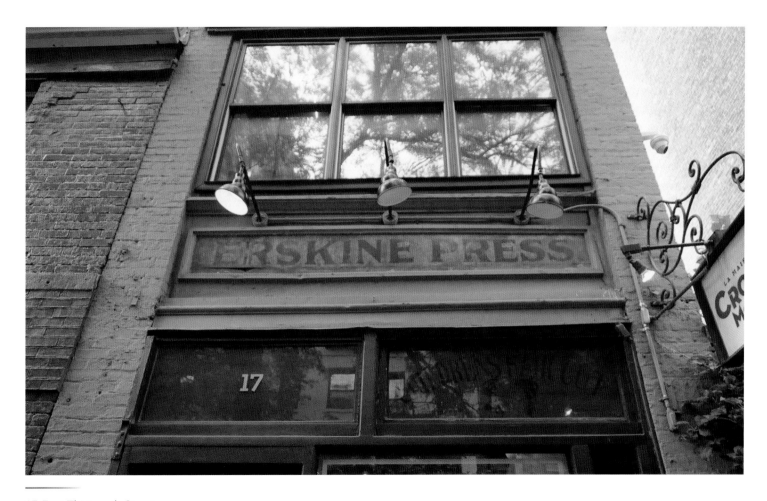

17 East Thirteenth Street

ERSKINE PRESS

The Erskine Press ghost sign on a diminutive building built in 1911 is a reminder of Greenwich Village's literary past. Small print shops and publishers served writers that included Edna St. Vincent Millay, Thomas Wolfe, and e. e. cummings.

The small press, run by Scottish immigrant Archibald Erskine, moved here from a few doors away when the building was completed. In 1944 author Anaïs Nin and her partner Gonzalo Moré moved in and started Gemor Press to publish her work.

"It was a small, two-story house," the author wrote in *The Diary of Anaïs Nin*, vol. 4, *1944–1947*. "The small house was painted green. There was a large front window, big enough for displays, and it could be fixed to exhibit our beautiful books."

As time passed, Nin's writing was hindered when she was forced to assume the responsibilities of the press. "The press collapsed under a mountain of debts," she wrote. "It was closed" (Nin 1972).

HART'S PRINTERS' ROLLERS

In the early nineteenth century, rollers replaced balls as a means to spread ink evenly on a printing plate. Henry L. Hart founded a printers' rollers business in Rochester, New York, and by 1918 Hart's son William opened Hart's Printers' Rollers in SoHo.

The company name is painted horizontally and vertically. Hart manufactured rollers here until about 1960, when the factory moved to Brooklyn. The business closed in 1997.

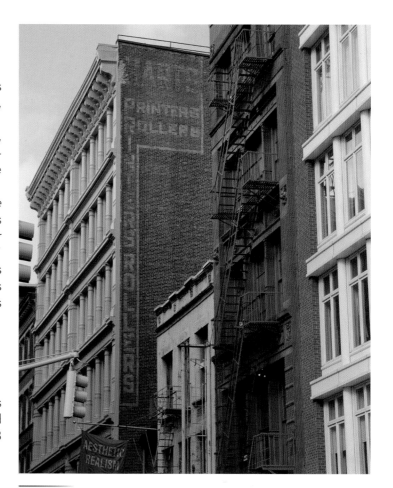

137 Greene Street

120–124 Prince Street

HERMAN LEFF PRINTING AND STATIONERY

Herman Leff ran a printing and stationery business in SoHo from the early 1900s to about 1950, when Irving Schreiber took over the business. Lithography and engraving services were offered along with office supplies and paper and twine. The print shop was located on the second floor. Schreiber closed the business in the 1970s.

65

KOPPER'S CHOCOLATE

Kopper's Chocolate was founded in 1937 by Fred "Pappi" Stern and European chocolatier David Kopper. The company was named Kopper's because they felt a name starting with a "K" sounded strong and would be successful. Kopper left the company shortly after it was formed to open a separate business uptown.

In 1980, Kopper's moved its factory from its longtime Waverly Place location to Clarkson Street, where its sign has survived. Kopper's remained a family business for three generations until 2016, when it was sold to Nuts.com and moved to Cranford, New Jersey.

B. FISCHER & CO.

German immigrant Benedickt Fischer came to the US as a teenager in 1855. Fischer built a successful coffee, tea, and spices dealership in Tribeca.

Fischer was also president of the American Encaustic Tile Company, an industry that creates ceramic tiles from different colors of clay. In 1905, Fischer's son William built an eight-story warehouse with the company's name displayed on two identical ceramic tile signs.

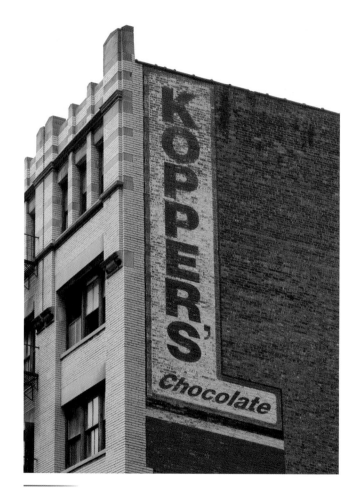

39 Clarkson Street

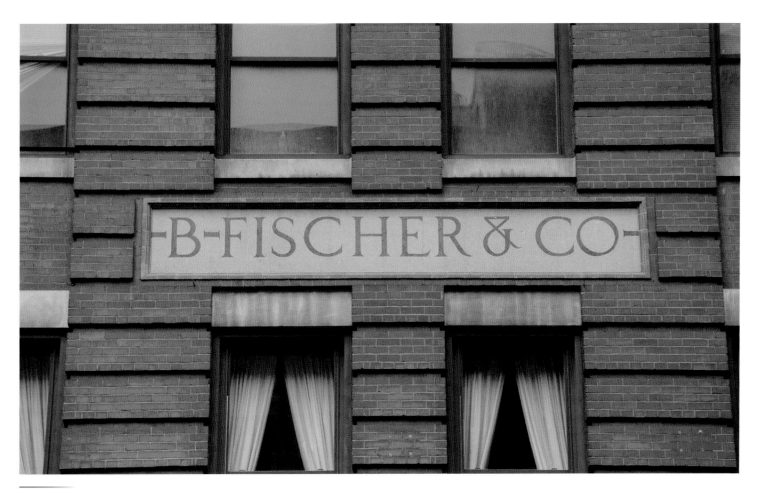

190 Franklin Street

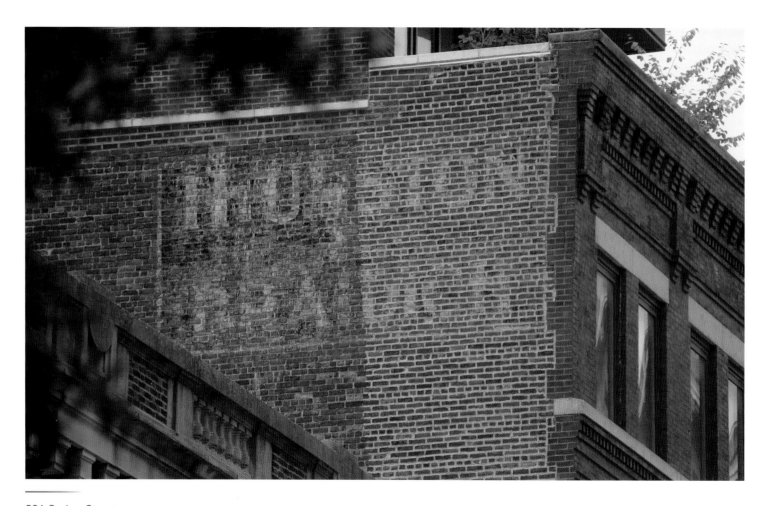

286 Spring Street

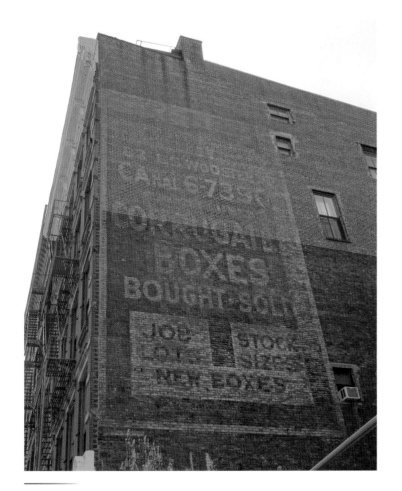

83–85 Wooster Street

THURSTON & BRAIDICH

Thurston & Braidich were importers of gum arabic, gum tragacanth, vanilla beans, tonka beans, and nutgalls, materials used for cooking and industrial purposes. William R. Thurston Jr. and Adolph F. Braidich started their business in downtown Manhattan in the mid-1800s. The firm moved to Spring Street in 1936, where it remained until 1958.

G&S FELDMAN CORRUGATED BOXES

Gabe and Sid Feldman are the G&S of G&S Feldman, a corrugated box company in SoHo. The company has moved to Brooklyn and New Jersey, and its sign, faded but still visible, has been largely covered by new ads.

MANHATTAN RAILWAY COMPANY STATION 5

In the 1870s, decades before the subways were built, the Manhattan Railway Company operated four lines of elevated railways, known as Els, along Second, Third, Sixth, and Ninth Avenues in Manhattan. The Second Avenue El was the last to be built.

The Manhattan Railway Company Station 5 powerhouse on Division and Allen Streets provided electricity for the trains. As the subways were built, sections of the elevated lines were closed. The final section of the Second Avenue Line closed in 1942. The bronze lettering of Station 5 remains on the brick wall of what is now a warehouse.

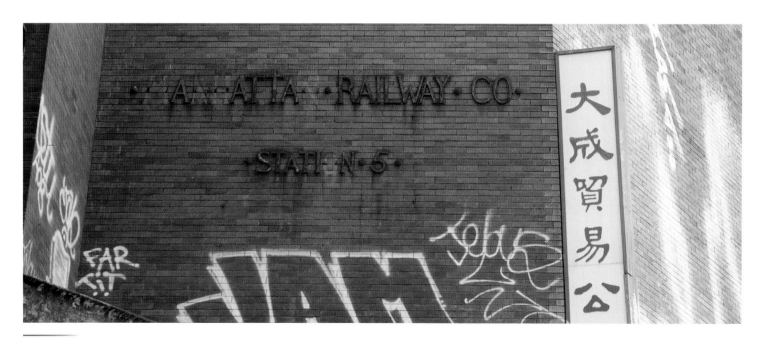

1 Allen Street

SPANJER SIGNS

Dutch immigrant John H. Spanjer opened Spanjer Signs on Canal Street in the early 1900s, a time when immigrants with entrepreneurial spirit flooded the Lower East Side. Signs were especially important to these new businesses because of the variety of languages spoken by their customers. Shopkeepers often bartered their wares in exchange for Spanjer's signs.

Spanjer moved its factory to 191 Chrystie Street in 1926; when 189 Chrystie next door was rebuilt after a fire, the company relocated there and used the signature of its founder as a model for its sign.

The ghost sign is in remarkable condition for its age. Its durability is due to its materials, said Spanjer president Steve Silverberg. The letters are made of melamine, an organic material, held in place by stainless steel channels. Unlike more modern materials, the melamine letters have not deteriorated after decades (Mastropolo 2018).

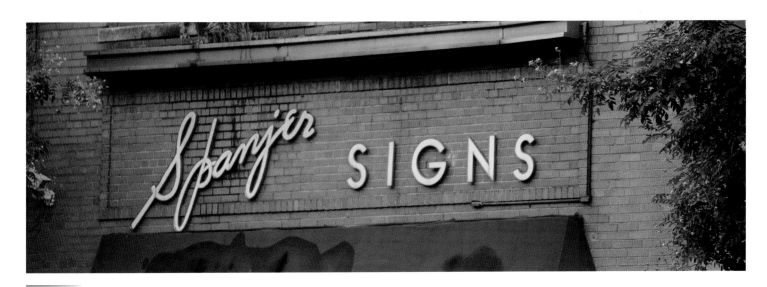

189 Chrystie Street

IDEAL GLASS

Today Ideal Glass is an art collective and gallery in the East Village. Its murals champion social issues. Above its doors is a ghost sign of the glass shop that operated here in the 1960s.

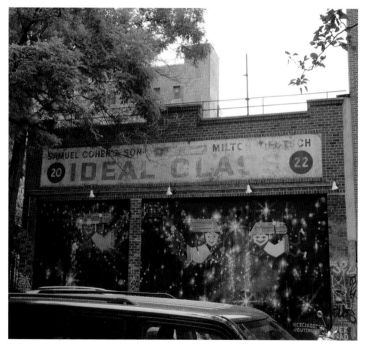

20–22 East Second Street

S. OPPENHEIMER

In the late 1800s, sausage casings were made from sheep, lamb, cattle, and hog intestines. One of the largest casings manufacturers was Sigmund Oppenheimer, a German immigrant who founded S. Oppenheimer & Co. in Chicago in 1868. In the 1870s, Oppenheimer opened a casings factory in a three-story building on the Lower East Side.

The loading dock, designed for horse-drawn carriages, is now a garage. Above it is one of the city's oldest painted signs. The sign above the door on the left once read "Office of / S. Oppenheimer." The sign on the right reads "S. Oppenheimer." Hygrade Food Products purchased the company in 1963.

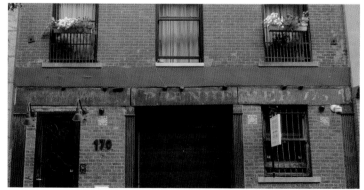

170 Eldridge Street

GROSVENOR PRIVATE BOARDING STABLE

By the late nineteenth century, horse-drawn carriages were the main mode of transportation in New York, with about 75,000 horses and 4,500 stables in the city. Stables were built to house the horses near the homes of their wealthy owners. Today most stables have been demolished or transformed into residences. But ghost signs remain downtown that evoke the horse-and-buggy days.

The Grosvenor Private Boarding Stable in Greenwich Village was built in the early 1800s as a carriage house. Grooms or drivers would have lived on the floors above the stables. By 1900 the building was converted to a residence, home to designer Margaret Armstrong.

The Grosvenor acquired its reputation as a residence for show business folks when British Shakespearean actor Maurice Evans purchased the house in 1949. Evans sold the building in 1965 to playwright Edward Albee, already famous for his play *Who's Afraid of Virginia Woolf?*

Albee sold the house in 1968 to composer and lyricist Jerry Herman, who wrote the scores for *Hello, Dolly!*, *Mame*, and *La Cage aux Folles*.

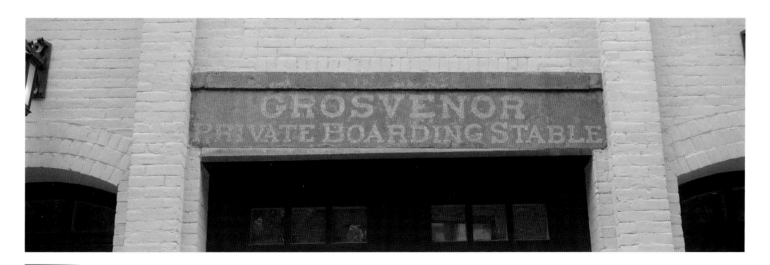

50 West Tenth Street

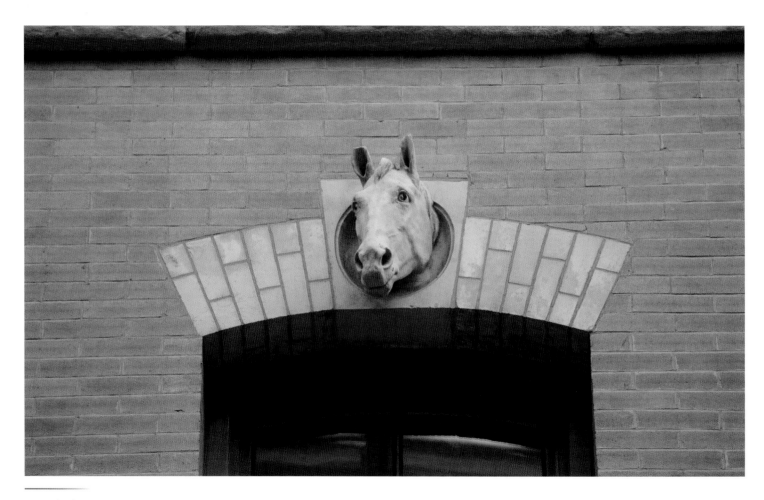

129 Charles Street

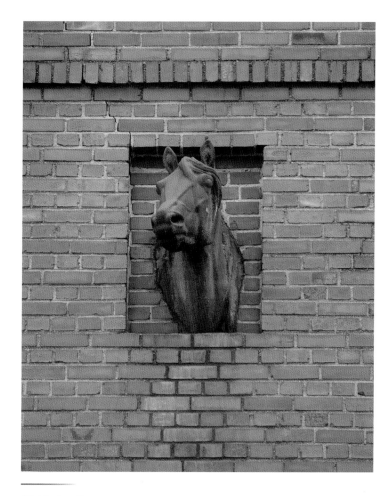

49 Market Street

H. THALMAN STABLE

The horse head sculpture emerging from a keystone announces that this Greenwich Village building once housed a stable. Architect Henry Andersen designed the building for Herman Thalmann, whose name—minus the last "n"—is engraved in a stone plaque above what were two stable doors and an entranceway. The Thalmann family lived on the upper floors of the four-story building.

Thalmann sold the building in 1902. It was converted to a garage and machine shop in 1950 and became a photography studio in 1972. Today the building is a private residence, its stable converted to a two-car garage.

DEPARTMENT OF STREET CLEANING STABLE

There were no fancy grooms or drivers for the horses at this Market Street stable near the East River. Built in the 1890s, the building was leased as a horse stable by the Department of Street Cleaning in 1895.

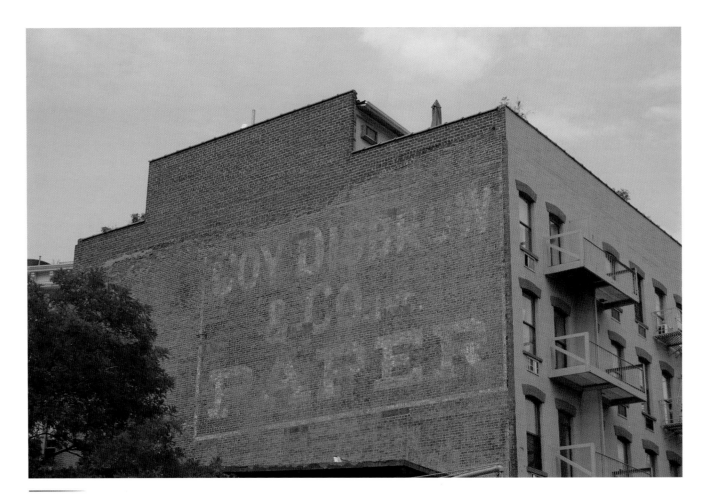

690 Greenwich Street

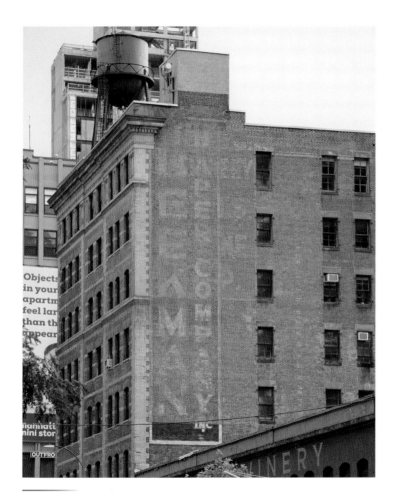

137 Varick Street

COY DISBROW PAPER

The five-story building in Greenwich Village was built as a tenement ca. 1868, a time when the Ninth Avenue elevated trains ran down Greenwich Street's center. That convenience and the proximity to the Hudson River made Greenwich Street an ideal location for paper manufacturers.

Coy Disbrow was founded in 1922 by Robert Henry Coy and Hamilton Thomas Disbrow. The company's first location was on Canal Street. It moved to Greenwich Village in 1930. Both Coy and Disbrow died in 1942, and the company relocated to Lafayette Street in 1968. The building was converted to apartments in 1977.

BEEKMAN PAPER

Though the five-story-tall Beekman Paper ghost sign towers over Varick Street, the company took its name from its original location, 56 Beekman Street. Founded in 1907 by Max and Alma Greenbaum, the company moved to Varick Street in 1926, where it remained until the late 1990s.

CHAPTER THREE: MEETING

224 Thompson Street, 1942. *Courtesy of the Farm Security Administration, Office of War Information Photograph Collection, Library of Congress, LC-DIG-fsa-8d21706*

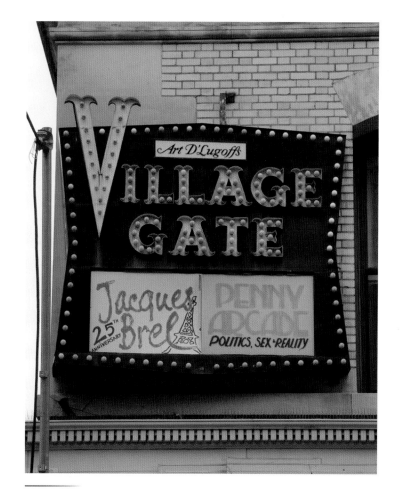

158 Bleecker Street

VILLAGE GATE

Impresario Art D'Lugoff opened the Village Gate in 1958 on the ground floor and basement of the Mills House No. 1, a former hotel for homeless men. The basement had been the hotel's laundry room. By the time the Village Gate closed in 1994, it had become a Greenwich Village icon.

The Village Gate featured the biggest names in rock, jazz, folk, and Latin music along with comedy and theatrical shows. The list of performers includes Jimi Hendrix, John Coltrane, Duke Ellington, Lenny Bruce, Miles Davis, Pete Seeger, and John Belushi.

The Village Gate sign endures on the corner of Bleecker and Thompson Streets. Placards on the sign advertise two of D'Lugoff's favorite shows: *Jacques Brel Is Alive and Well and Living in Paris* and performance artist Penny Arcade's *Politics, Sex & Reality*.

CAFE FIGARO

Cafe Figaro was opened in 1957 by husband and wife Tom Ziegler and Royce Powell. Customers of the Greenwich Village coffeehouse included Bob Dylan, Lenny Bruce, Jack Kerouac, and Salvador Dalí. Beat poets and folk singers would pass a basket after performing.

A rent hike forced the Figaro to close in 1969. A sandwich shop and an ice cream parlor inhabited the spot until the name was revived in 1975. Cafe Figaro closed for good in 2008. Embedded in the sidewalk is wood-inlaid lettering with the café's name.

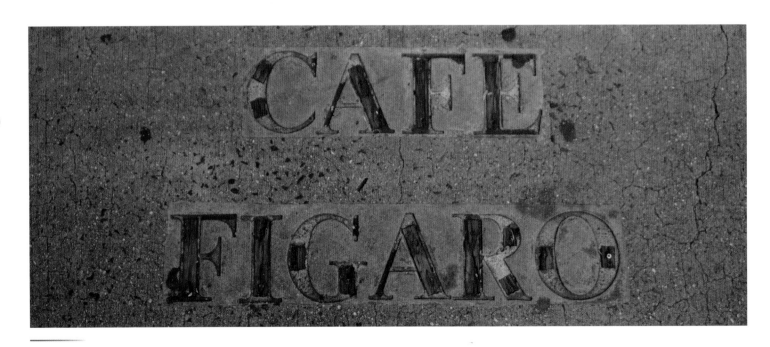

186 Bleecker Street

BOWERY SAVINGS BANK

The Bowery Savings Bank headquarters was designed in a Roman classical style by Stanford White. Completed in 1895, the building features the bank's name carved high above huge Corinthian columns. The name was placed high to be seen by passengers on the Third Avenue elevated trains, which operated on the Bowery from 1878 to 1955.

The *New York Times* explained that banks were designed in such grand fashion "to inspire confidence. When the United States economy collapsed in the Panic of 1893, many people blamed banks for the depression that followed and withdrew their money. So, banks built in that era (until the end of the Great Depression, when banks began to demystify themselves with glass-fronted branches) were meant to suggest strength, as if they had been there forever" (Hughes 2005).

Bowery Savings moved its headquarters to Forty-Second Street in 1923 but continued as a bank here until 1982.

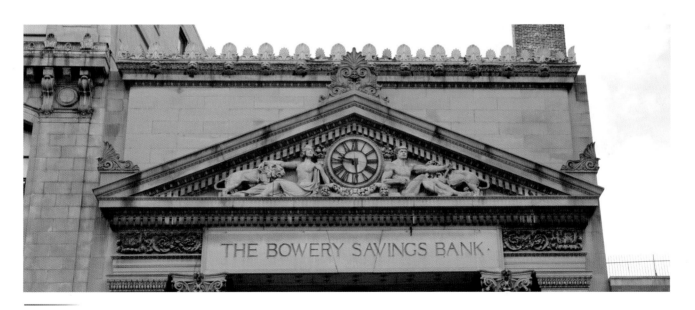

130 Bowery

INDEPENDENT KLETZKER BROTHERLY AID ASSOCIATION

In the late nineteenth century, immigrants from central Europe often arrived in need of financial help. Self-help organizations, known as *landsmanshaftn*, were established to find medical care and housing, provide funds to start a business, teach English, and locate friends and family from the Old Country. Each group served immigrants from a specific town.

The Independent Kletzker Brotherly Aid Association was formed in 1892 by Jewish immigrants from the Belarus city of Kletsk, or Kletzk, as it was known in Yiddish. The organization's name is still displayed on the building's red cornice. Note the outline of the Star of David below the sign, which was removed during renovations.

82

5 Ludlow Street

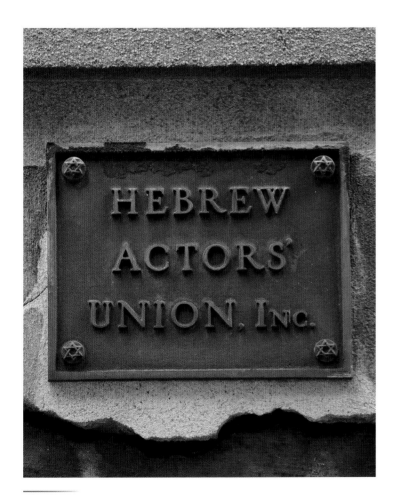

31 East Seventh Street

HEBREW ACTORS' UNION

Yiddish theater thrived downtown in the 1920s; theaters on Second Avenue between Houston and Fourteenth Streets were part of the Yiddish Theater District. Playhouses hosted as many as thirty shows a night, featuring performances in Yiddish of plays, comedies, operettas, and dramas. In its early days, performers were treated poorly by theater managers. Actors could be fired without notice, and their salaries depended on the success of the show.

The Hebrew Actors' Union was formed in 1897, the first performing arts union in the US. The union moved to its East Village building in 1923. That year, architect Victor Mayper created a new facade for the building in the neoclassical style. The union was a meeting place for Yiddish performers that included Molly Picon, Stella Adler, and Paul Muni. It was a place where actors could eat, play cards, and discuss future productions.

The Yiddish theater was in decline by the mid-1930s as audiences moved to Broadway and movies for entertainment. Yiddish theaters closed and their actors moved on to the non-Yiddish stage or Hollywood. In 2005 the union was labeled nonoperational by its umbrella union, the Associated Actors and Artistes of America.

FIRST ROUMANIAN-AMERICAN CONGREGATION

More than 75,000 Jewish immigrants from Romania settled on the Lower East Side between 1881 and 1914. Most lived in the fifteen-block area bounded by Allen, Ludlow, Houston, and Grand Streets, known as the Romanian Quarter. The building at 89–93 Rivington Street that housed the First Roumanian-American Congregation was home to a synagogue and church before it became a place of worship for Romanian Jewish immigrants.

In 1902 the congregation purchased the building, which soon became famous as the "Cantors' Carnegie Hall" for the acoustics created by its high ceiling. Jan Peerce and Richard Tucker sang there before they became famous opera singers. Actors George Burns and Edward G. Robinson were members; comedian Red Buttons sang at the synagogue.

Membership declined toward the end of the twentieth century as the neighborhood changed and the synagogue deteriorated. On Jan. 22, 2006, the roof of the main sanctuary caved in. After demolition in March 2006, the rear wall, with a Star of David in stained glass and the carved stones from the entrance arch, were about all that remained. The entrance arch was incorporated into the building next door at 95 Rivington Street.

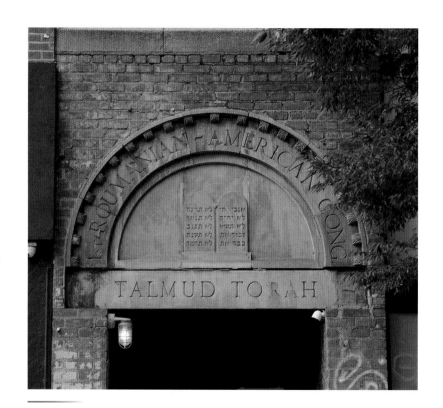

95 Rivington Street

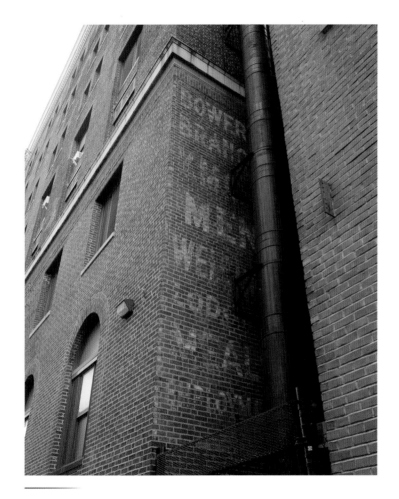

8 East Third Street

BOWERY BRANCH YMCA

The Bowery was rife with drinking, gambling, and homelessness when the Bowery Branch of the Young Men's Christian Association opened here in 1915. A bulletin board in the lobby listed the services it provided: "Wholesome food, bath, physical examination, clean bed, clean clothes, barber service, social times, employment, credit until pay day, encouragement, dormitory, religious meetings, educational classes, reading room, helpful recreation, new friends, savings account, self-reliance" (Ackerson et al. 2012).

The Bowery Branch YMCA was a pioneer in providing this help to homeless men. YMCAs at the time routinely offered only reading rooms, religious services, and some recreational activities.

On the outside wall facing an alley is a narrow painted sign partly covered by a large pipe. The sign advertises lodging, meals, and employment to men in need. The sign survives, although the YMCA sold the building to the city in 1947.

FOURTEENTH WARD INDUSTRIAL SCHOOL

In his 1890 book *How the Other Half Lives: Studies among the Tenements of New York* (Riis 2015), social reformer Jacob Riis described downtown Manhattan's "Street Arabs": the orphaned or abandoned boys who were often the children of prostitutes and drug addicts. "The Street Arab has all the faults and all the virtues of the lawless life he leads. Vagabond that he is, acknowledging no authority and owing no allegiance to anybody or anything, with his grimy fist raised against society whenever it tries to coerce him, he is as bright and sharp as the weasel, which, among all the predatory beasts, he most resembles."

To help these children, philanthropist John Jacob Astor III and his wife, Charlotte, donated thousands of dollars to the Children's Aid Society, an organization that provided food and lodging to homeless youths.

When his wife died, Astor memorialized her by building a school for the society in 1888 in the city's Fourteenth Ward, a poor Italian neighborhood. Astor hired architect Calvert Vaux, who helped design Central Park, to erect a Victorian Gothic building as a school for the children of the slums.

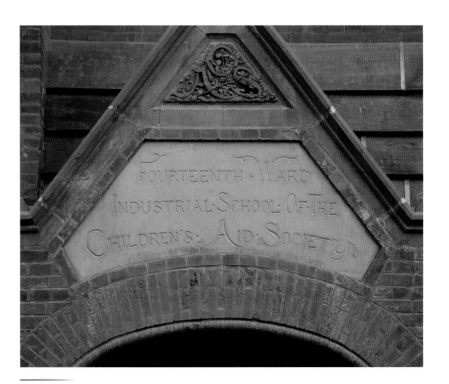

256 Mott Street

SHULMAN SCHOOL

Morris A. Shulman founded Shulman's School of Commerce on the Lower East Side at 311 East Broadway. The school served Jewish immigrants in the early twentieth century, offering classes in the English language, typing, stenography, and accounting.

Its ghost sign facing Second Avenue may have been visible to riders on the Third Avenue elevated trains as they approached the school. Vine leaves camouflage the sign for most of the year.

51 East Second Street

NORTHERN DISPENSARY

The Northern Dispensary is built on a triangle of land bounded by Waverly Place, Christopher Street, and Grove Street in Greenwich Village. The dispensary was built in 1831 on land donated by the city, which had only one health clinic at the time. The Northern Dispensary property carries a deed restriction that it can be used to provide medical care to the "worthy poor."

A marble plaque above the entrance describes its mission: "Heal the Sick." It was named the Northern Dispensary because Greenwich Village was then considered the northern part of the city. The dispensary cared for thousands of patients in the 1800s; Edgar Allan Poe was purportedly treated for a winter cold in 1837.

The dispensary later became a dental clinic. After refusing to treat a man with AIDS in the 1980s, the clinic was sued, fined thousands of dollars, and was closed.

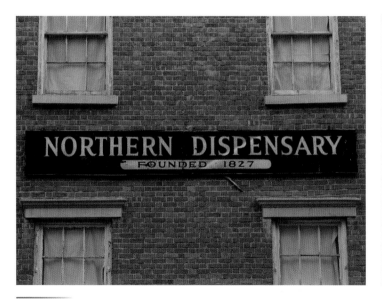

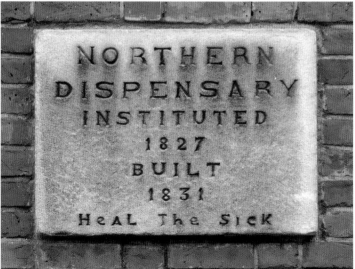

165 Waverly Place

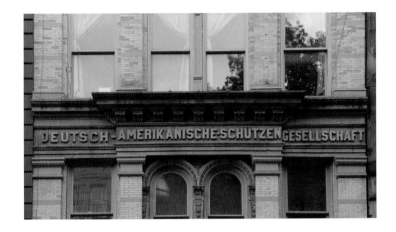

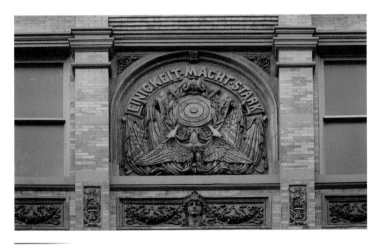

DEUTSCH-AMERIKANISCHE SCHÜTZEN GESELLSCHAFT (GERMAN-AMERICAN SHOOTING SOCIETY)

The German-American Shooting Society building in what was Little Germany opened in 1888. The sport of shooting is a German tradition, called "Germany's golf." There were dozens of German shooting clubs and societies in the New York area in the late 1800s.

The building was designed by architect William C. Frohne in the German Renaissance Revival style. A terra-cotta bas relief at the fourth floor shows an eagle flanked by the American and German flags. Above is a target backed by crossed rifles with the engraved words *Einigkeit Macht Stark*, or Unity Makes Strength.

The German American population of Little Germany began to decline in the 1860s as the more affluent moved north to Yorkville. On June 15, 1904, more than 1,000 German Americans, mostly women and children, died during a day trip to Long Island when the *General Slocum*, a paddle steamer, sank in the East River. The community began to unravel, since many people lost a family member in the tragedy.

12 St. Marks Place

ROCCO RESTAURANT

Rocco Restaurant opened in 1922 in Greenwich Village, a three-generation eatery serving southern Italian food. Owner Rocco Stanziano ran the restaurant until 1966, when nephew Gianni Respinto took over. In 1992, Respinto's nephew Antonio DaSilva continued the restaurant's reputation for great food and reasonable prices.

A rent hike forced the restaurant to close at the end of 2011. Chefs Mario Carbone and Rich Torrisi acquired the space and reopened it as Carbone. The original Rocco sign has been retained, but the neon tubing illuminating the Rocco name has been removed, replaced by "Carbone."

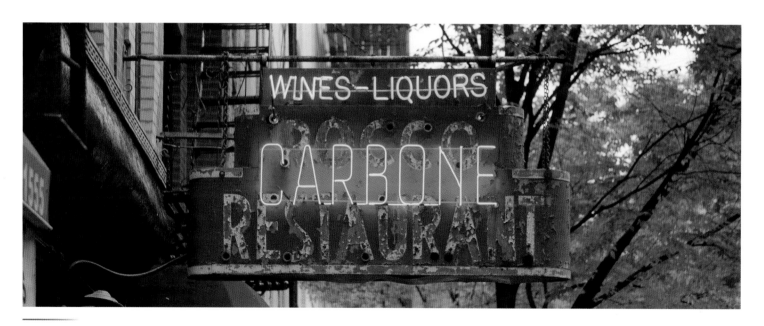

181 Thompson Street

FAMOUS OYSTER BAR

The two neon signs of the Famous Oyster Bar lit the corner of Fifty-Fourth Street and Seventh Avenue for fifty-five years before it closed in 2014. Founder Angelo Agmonostopoulo opened the seafood restaurant in 1959. Partner Ajit Saha took over the Oyster Bar in 2010 after Agmonostopoulo died. The restaurant closed after a series of rent increases.

Ryan Chadwick, co-owner of Lower East Side seafood restaurant Grey Lady, bought the signs at auction. They were installed above Grey Lady in April 2014.

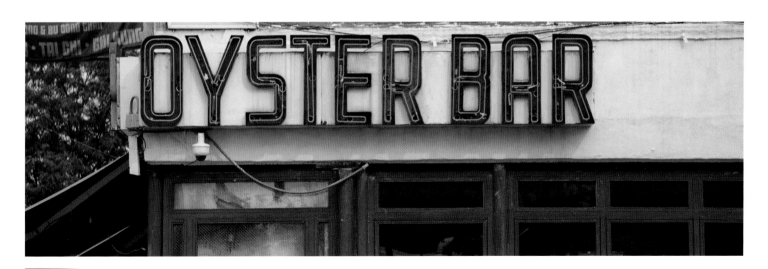

77 Delancey Street

RIVERVIEW HOTEL

Visitors to the Jane, a boutique hotel on the corner of Jane and West Streets in Greenwich Village, would hardly imagine the Georgian-style building's history. Architect William A. Boring designed the building, built from 1906 to 1908, for the American Seamen's Friend Society Sailors' Home and Institute as a hotel for sailors who docked at the busy Hudson River piers nearby.

92

 The religious organization hoped to provide sailors with an alternative to the brothels and saloons in the area. A beacon on the roof could be seen from the river. On April 18, 1912, three days after the sinking of the RMS *Titanic*, survivors were welcomed there.

 In 1944, the YMCA took over the building. By the 1990s it became the Riverview Hotel. Its sign, once lit by neon, remains on the corner above the lobby level of the Jane.

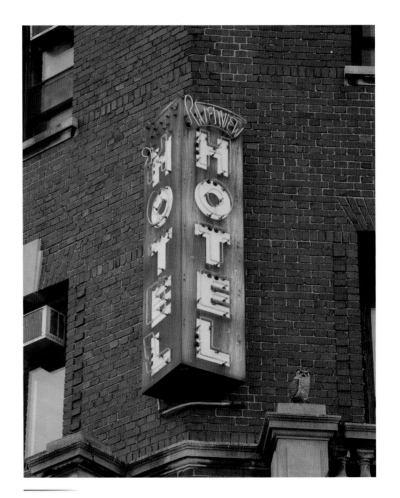

113 Jane Street

VILLAGE PLAZA HOTEL

The Village Plaza Hotel opened in the early 1960s on Washington Place, a tree-lined street in Greenwich Village. Its proximity to Washington Square Park and New York University belies the fact that the Village Plaza was a seedy, single-room-occupancy welfare hotel.

The 1915 building was originally the Hotel Colborne. The

Village Plaza's ghost sign, visible from Sixth Avenue, cites air conditioning as the hotel's main feature. A 1967 *New York Times* article provides a glimpse of the hotel's lobby: "The Village Plaza, 79 Washington Place, has no doorman. A flaking sign by the tiny reception desk announces 'Television for Rental' amidst a forest of other signs: 'No Refunds,' 'All Rents Must be Paid in Advance,' 'No Checks Cashed,' 'No Outgoing Calls for Transients.'"

79 Washington Place

FREE PUBLIC BATHS OF THE CITY OF NEW YORK

A *New York Times* story in 1906 described how important free public baths were to the poor of the city. "An unusual feature in the heat wave yesterday was the crowd which rushed upon the public baths . . . at the Eleventh Street baths people stood in lines four deep. By and by the crush became so great that, despite the eighty-seven sprays and numerous tubs in each of these places, the police reserves had to be called to preserve order. The lines broke, and as each batch came out of the baths two or three hundred rushed to get in. Order was finally evolved [sic] by the police, and it was not necessary to make any arrests."

At the start of the twentieth century, poor immigrants on New York's Lower East Side often did not have bathing facilities. To keep people clean and cool, New York built more than a dozen public baths in the early 1900s. The Eleventh Street facility was completed in 1905.

The City Beautiful movement of the era advocated the construction of elaborate, monumental public buildings. The belief was that imposing structures would encourage good moral behavior and improve the quality of life of immigrants.

The city spared no expense in building the Eleventh Street baths. Inspired by the ruins of ancient Roman baths, architect Arnold Brunner designed the baths in the neo-Italian Renaissance style. Light-colored Indiana limestone was used to convey a sense of cleanliness. Separate marked entrances allowed men and women to enter and leave without ever crossing paths. On either side of the building's carved letters are cartouches that display tridents and fish.

By the mid-twentieth century, most tenements had private bathrooms, and the need for public baths diminished. The city closed the Eleventh Street baths in 1958.

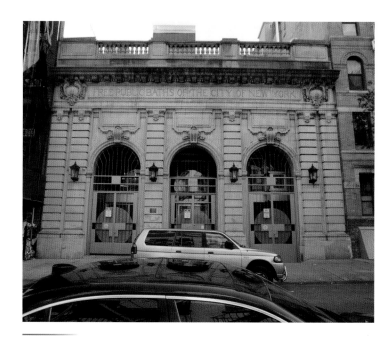

538–540 East Eleventh Street

EMERALD PUB

Opened in 1972, the Emerald Pub was a low-key SoHo haunt that closed in 2015. Its sign was replaced with one for the Terminal Bar for director Martin Scorsese's 1985 film *After Hours*.

MCGOVERN'S BAR

McGovern's Bar opened in the early 1960s. It closed after more than two decades, but the bars that succeeded it have maintained its ghost sign.

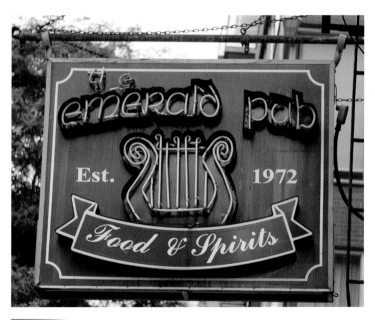

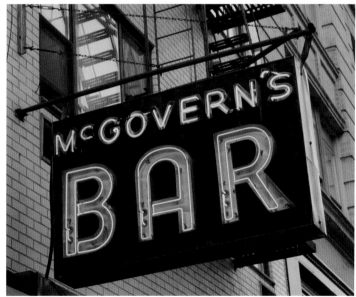

308 Spring Street

305 Spring Street

EAR INN

There has been a tavern at the historic James Brown House since the late 1890s. Brown was an African American aide to George Washington during the Revolutionary War. Brown sold tobacco from the ground floor of his two-and-a-half-story federal-style building. After Brown died, the building was sold and the shop became a brewery and later a bar and restaurant that served sailors from the nearby Hudson River ports.

Known informally as the Green Door, the tavern became a speakeasy during Prohibition. After Prohibition, the bar re-opened. The neon sign above the entrance simply read "Bar."

In 1977, owners Martin Sheridan and Richard "Rip" Hayman decided the bar should have a name. They named it the Ear Inn after *The Ear*, a music magazine published upstairs. The building had been landmarked in 1969, and Hayman used black paint to cover the round parts of the "B" to avoid the extended review that is required for new signage.

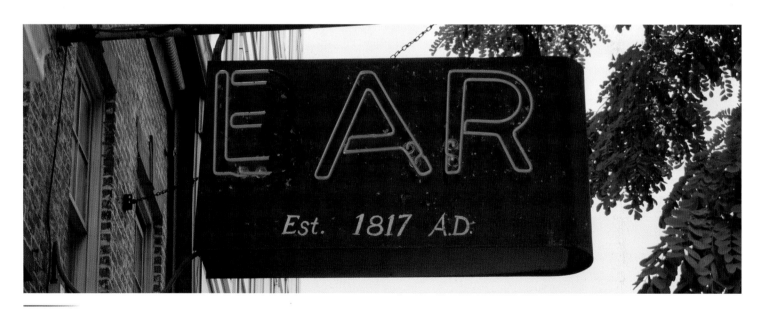

326 Spring Street

THE PIANO STORE

When this bar, restaurant, and music venue opened on the Lower East Side in 2002, it kept the ghost sign of the previous occupant, the Piano Store, and named itself Pianos.

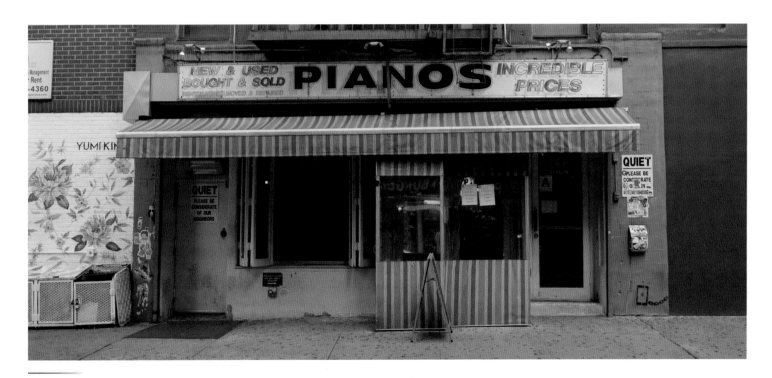

158 Ludlow Street

CHAPTER FOUR: DISCOVERIES

LOFT'S CANDIES

Though it is barely remembered today, Loft's Candies was the largest manufacturer and seller of candy in the world in the 1920s, so big that it acquired Pepsi-Cola in 1931. British immigrant William Loft opened his first store in Lower Manhattan in 1860 and built a candy factory in Long Island City. By 1957, Loft's operated 300 stores in the US, but by 1990 all the stores had closed.

In 2016, the vinyl awning for discount dress shop Lilly's Boutique was removed during renovation, revealing the forgotten Loft's ghost sign.

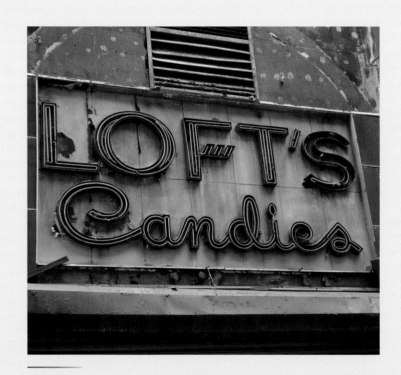

86½ Nassau Street

I&J KRAMER CHILDREN'S WEAR

For decades Avenue A was the place to shop for baby carriages, strollers, cribs, and toys. Ben's Juvenile Mart and Schachter's Babyland were a few doors apart near East Sixth Street. Schneider's Juvenile Furniture on East Second Street was one of the last to leave the area in 2004.

In the 1930s, I&J Kramer Children's Wear had a corner store on Avenue A. Glass signs with lettering edged in gold leaf described I&J's merchandise: "Infants' Wear, Children's Dresses, Boys' Suits, Underwear, and Novelties."

The ghost signs were discovered in 2016 by the owners of 2A Bar. "We were simply doing routine renovations on the facade of the building to fix our windows," Laura McCarthy told *Bedford+Bowery*. "Lo and behold, we found these signs hiding out for decades upon decades underneath" (Mastropolo 2018).

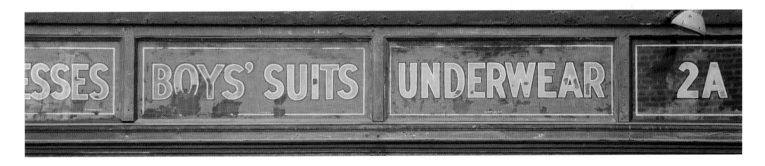

25 Avenue A

WAH LIN CHINESE LAUNDRY

The first large wave of Chinese immigration to the US came in the mid-1800s. The new immigrants faced anti-Asian discrimination and restricted labor markets. Chinese Americans were banned from jobs in mining, fishing, farming, and manufacturing.

A laundry became the business of choice for Chinese immigrants. The exhausting work over boiling kettles of water was not appealing to white male workers, who considered washing clothes to be women's work. By 1900, one in four Chinese men worked in a laundry.

As you enter the Antler Beer & Wine Dispensary, you pass under a faded hand-painted sign for the Wah Lin Chinese Laundry. In 2015, Antler owner Kate Steinmetz told *Bedford+Bowery* how the sign was discovered. "I had recently bought the bar from my former boss. He uncovered the sign when he took over the space. It had previously been covered by the metal gate. I love it so much I refuse to put a sign for the bar over it" (Mastropolo 2015).

123 Allen Street

STAR KITCHEN AND BAR EQUIPMENT

For much of the twentieth century, the city's Restaurant Supply District was concentrated along the Bowery. Star Kitchen and Bar Equipment operated here from 1936 until the mid-1960s, followed by companies that included Allright Restaurant Equipment and Advance Kitchen Supply.

When restaurant furniture store Chair Up moved from the storefront in 2016, cleanup crews found a hand grenade and other WWII-era weapons in the basement. The removal of Chair Up's signage revealed painted glass signs that probably date back to Star's time in the building. The signs advertise restaurant supplies such as coffee urns, steam tables, and bar benches.

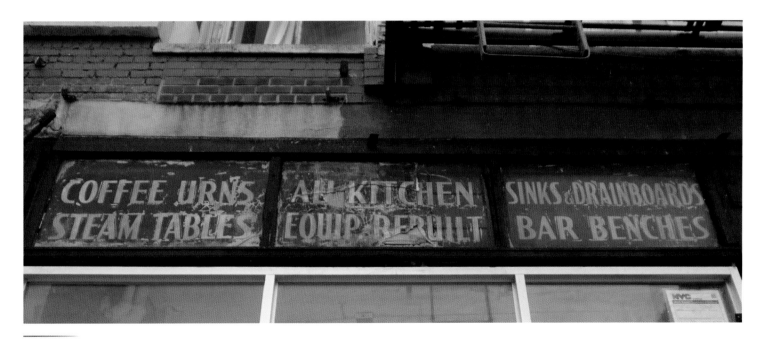

219 Bowery

KATZ'S DELICATESSEN

Katz's Delicatessen moved to its Houston Street location in the early 1900s, as Jewish immigrants arrived on the Lower East Side. In the 1930s there were about 1,500 Jewish delicatessens in New York; Katz's always ranked among the best. Local families and stars of the Yiddish theater flocked to Katz's for pastrami sandwiches, hot dogs, and knishes.

In 2016, the Houston Street buildings next to Katz's were demolished for an eleven-story residential building. During the clearing of the site, a Katz's sign was discovered that may have been above its entrance decades ago. Much of the sign is faded, but what can be read are "Katz's" and "Fabric." Fabric in a delicatessen?

The aged Katz's sign on the deli's Ludlow Street side provides a clue. It advertises "wurst fabric," believed to be an Americanization of a Yiddish term for "sausage factory."

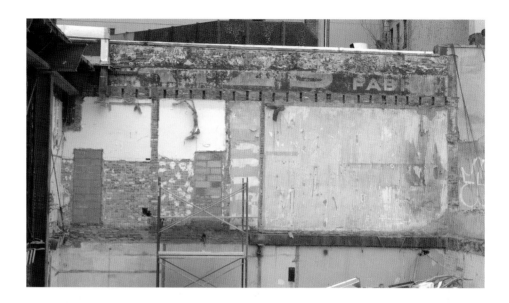

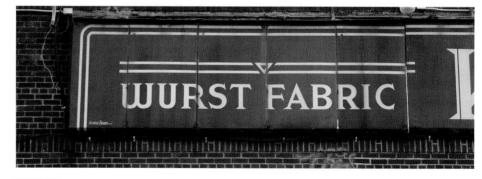

205 East Houston Street

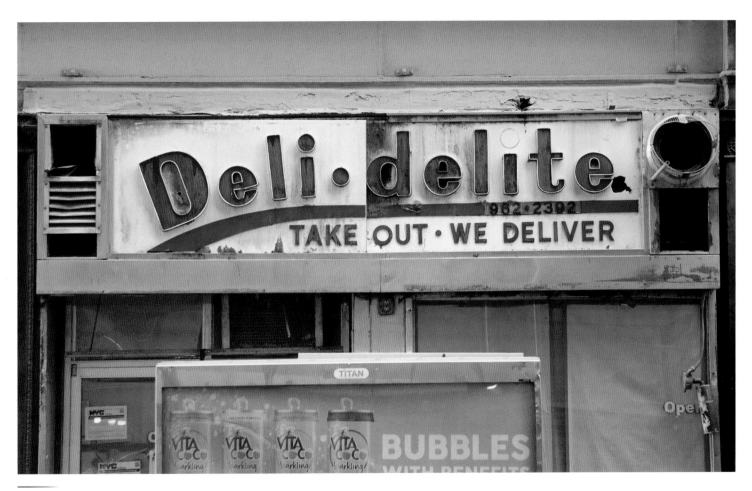

3 Maiden Lane

DELI DELITE

Few Jewish delis remain in New York. Deli Delite is an example of how much the term "deli" has changed from what it meant in Katz's day. While delis today prepare sandwiches, they are often small grocery stores, selling potato chips, newspapers, candy, gum, and tobacco products. Many delis are strictly takeout; some provide tables.

Deli Delite served the Financial District in the 1980s. When the sign for a pizzeria was removed during renovation, the battered Deli Delite sign was given a new, albeit temporary, life.

J&R MUSIC WORLD

J&R stands for Joseph and Rachelle Friedman, newlyweds who in 1971 opened their first store selling records. In its prime, J&R Music World spanned nine storefronts on Park Row across from City Hall. J&R sold CDs, DVDs, digital cameras, computers, and cellphones.

The terrorist attack of September 11, 2001, just blocks away, and a tough consumer electronics environment forced J&R to close in 2014. The storefronts have been demolished to make way for a fifty-four-story condominium building.

During demolition a sign was revealed that may have greeted customers at the original store. Audiotapes were advertised, but "needles" hints at vinyl's popularity. The word "stereo" is obscured above the music notes.

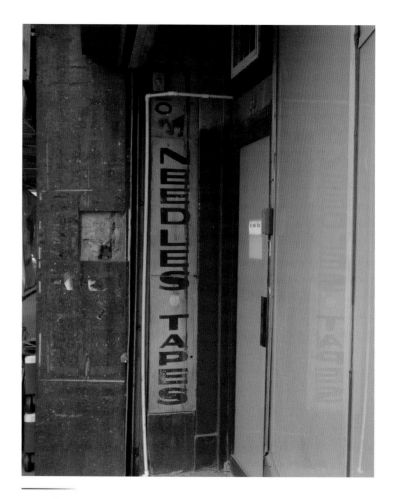

33 Park Row

MRS. A. SWINTON AND SAMUEL TUCK

During renovations in 2014, a sign for the HF Lo Laundry was removed from the Greenwich Village building facade on the corner of Bleecker and Christopher Streets. A palimpsest, or double ghost sign, was revealed that is one of the oldest in the city. A sign for Samuel Tuck was painted over by one for Mrs. A. Swinton. The sign's number 302 refers to an earlier numbering system used on Bleecker Street.

In the mid-1850s, Samuel Tuck was an importer and dealer of embroidery, lace, and other "fancy goods." Mrs. A. Swinton was a millinery shop in the mid-1860s.

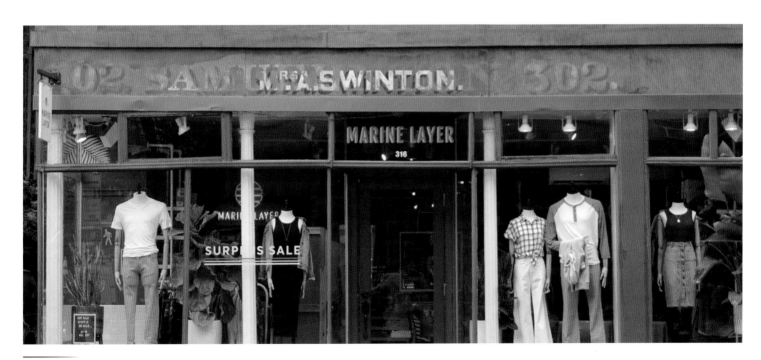

316 Bleecker Street

COHEN'S OPTICAL

In 1927, Jack Cohen sold ready-made glasses from his push-cart on the Lower East Side. Cohen's business prospered, and he founded Cohen's Optical on the corner of Delancey and Orchard Streets.

Cohen's vision, so to speak, was that glasses could be fashionable while improving your sight. The Cohen family began hand-dyeing eyeglass frames in different colors. The idea became so popular that the store changed its name to Cohen's Fashion Optical. The company has expanded to over one hundred stores but remains in its original location.

In 2015, signage was removed during renovations that exposed the old Cohen's Optical sign, erected before "Fashion" was added to its name. Its letters were in good shape, as were its retro eyeglass frames.

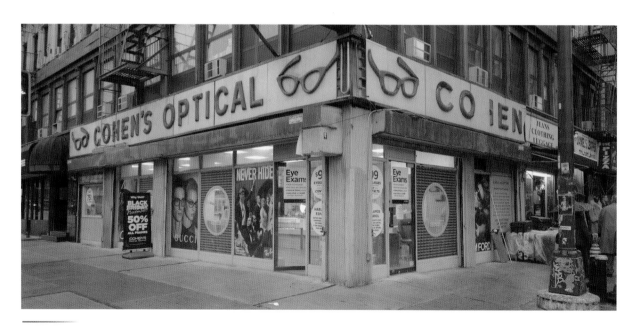

117 Orchard Street

RATNER'S

Ratner's was a kosher dairy restaurant founded by Jacob Harmatz and his brother-in-law, Alex Ratner, in 1905. Ratner's moved to Delancey Street in 1918. Its curmudgeonly waiters served cheese blintzes, mushroom barley soup, and schmaltz herring. Ratner's famous onion rolls were served on every table at every meal.

Ratner's was a favorite of Jewish entertainers. Its bright-orange neon sign, installed in 1957, welcomed Al Jolson, Fanny Brice, Groucho Marx, and Alan King. Gangsters Bugsy Siegel and Meyer Lansky were regular customers.

As the neighborhood changed, Ratner's business dropped off and the restaurant closed in 2002. After a Sleepy's Mattress shop closed on the site, a 2015 renovation uncovered the Ratner's ghost sign.

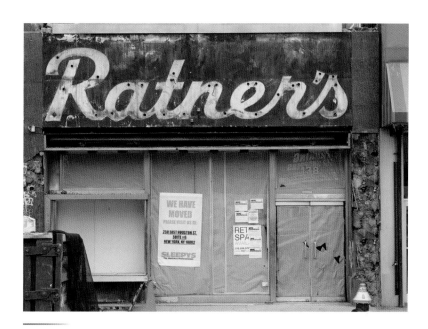

138 Delancey Street

CHAPTER FIVE: MAKE-BELIEVE

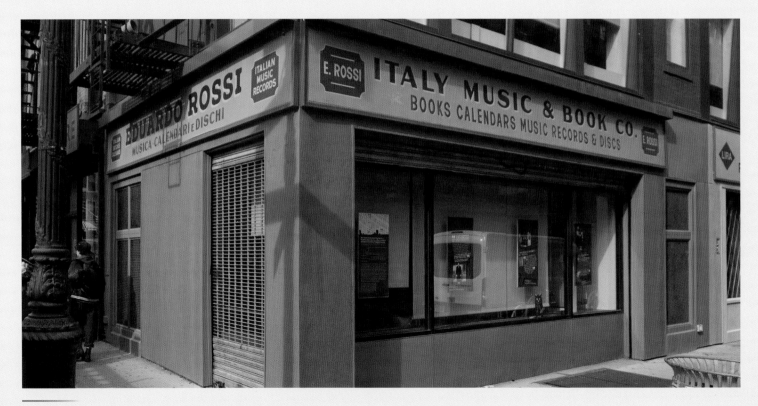

91 Orchard Street

620 East Sixth Street

PARODI CIGARS

The Parodi Cigar Manufacturing Company was founded on West Broadway in Greenwich Village in 1913. Parodis are thin, hand-rolled Italian cigars. Clint Eastwood is rumored to have smoked Parodis during the filming of his spaghetti westerns of the 1960s.

The Parodi sign in the East Village seems authentic. It mentions Parodi's New Jersey factory and has a "Seal of Quality" with Emilio Parodi's signature. The problem is that Quirino Parodi founded the company with two partners; there was no Emilio Parodi associated with the cigar maker.

The Parodi sign was painted during filming in the East Village of 1974's *The Godfather, Part II*. The film is both a prequel and sequel to *The Godfather*. Set designers transformed East Sixth Street between Avenues A and B into a Little Italy neighborhood of 1917. In the film, the young Vito Corleone, played by Robert De Niro, arrives from Sicily and starts his family business here. The Parodi sign, between Avenues B and C, can be seen in long shots of the street, looking east.

MOE'S MEAT MARKET

Artist Robert Kobayashi created pointillist paintings and folk art sculptures made of discarded cans that had held coffee, beer, and olive oil. In 1977, Kobayashi and his wife, photographer Kate Keller, bought a building in Little Italy. Its storefront had been Moe's Meat Market, a neighborhood butcher shop.

Kobayashi made the space his studio and gallery. Onlookers could see the changing array of Kobayashi's work through the front window.

Those who knew Moe's history may have thought a ghost sign for the shop hung above. Phyllis Stigliano, a principal in the gallery, told *Bedford+Bowery* that the sign was created for the filming on Elizabeth Street of 1990's *The Godfather, Part III* (Mastropolo 2015).

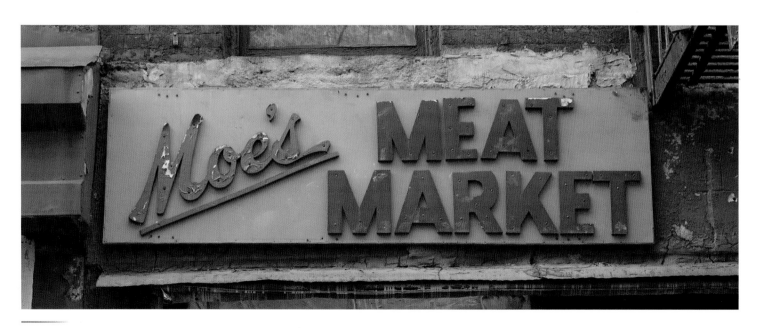

237 Elizabeth Street

Ready to Write a Book?

Our authors are as passionate as we are about providing new and intriguing perspectives on a variety of topics, both niche and general. If you have a fresh idea, we would love to hear from you, as we are continually seeking new authors and their work. Visit our website to view our complete list of titles and our current catalogs. Please visit our Author Resource Center on our website for submission guidelines, and contact us at proposals@schifferbooks.com or write to the address below, to the attention of Acquisitions.

Schiffer Publishing Ltd.

A family-owned, independent publisher since 1974, Schiffer has published thousands of titles on the diverse subjects that fuel our readers' passions. Explore our list of more than 5,000 titles in the following categories:

ART, DESIGN & ANTIQUES

Fine Art | Fashion | Architecture | Interior Design | Landscape | Decorative Arts | Pop Culture | Collectibles | Art History | Graffiti & Street Art | Photography | Pinup | Sculpture | Body Art & Tattoo | Antique Clocks | Watches | Graphic Design | Contemporary Craft | Illustration | Folk Art | Jewelry | Fabric Reference

MILITARY

Aviation | Naval | Ground Forces | American Civil War | Militaria | Modeling & Collectible Figures | Pinup | Transportation | World War I & II | Uniforms & Clothing | Biographies & Memoirs | Unit Histories | Emblems & Patches | Weapons & Artillery

CRAFT

Arts & Crafts | Fiber Arts & Wearables | Woodworking | Quilts | Gourding | Craft Techniques | Leathercraft | Carving | Boat Building | Knife Making | Printmaking | Weaving | How-to Projects | Tools | Calligraphy

TRADE

Lifestyle | Natural Sciences | History | Children's | Regional | Cookbooks | Entertaining | Guide Books | Wildlife | Tourism | Pets | Puzzles & Games | Movies | Business & Legal | Paranormal | UFOs | Cryptozoology | Vampires | Ghosts

MIND BODY SPIRIT

Divination | Meditation | Astrology | Numerology & Palmistry | Psychic Skills | Channeled Material | Metaphysics | Spirituality | Health & Lifestyle | Tarot & Oracles | Crystals | Wicca | Paganism | Self Improvement

MARITIME

Professional Maritime Instruction | Seamanship | Navigation | First Aid/Emergency | Maritime History | The Chesapeake | Antiques & Collectibles | Children's | Crafts | Natural Sciences | Hunting & Fishing | Cooking | Shipping | Sailing | Travel | Navigation

SCHIFFER PUBLISHING, LTD.
4880 Lower Valley Road | Atglen, PA 19310
Phone: 610-593-1777
E-mail: Info@schifferbooks.com
Printed in China

www.schifferbooks.com

ABE'S ANTIQUES

ABC Television came to the Lower East Side in 2014 and built the Abe's Antiques storefront for its fantasy crime drama series *Forever*. The show's main character, Dr. Henry Morgan, played by Ioan Gruffudd, is an immortal who helps the police solve crimes. Abe is Dr. Morgan's adopted son Abraham Morgan, played by Judd Hirsch. The doctor works in Abe's basement, hoping to find a way to reverse his immortality.

Forever, however, was hardly immortal. The show was canceled by ABC after one season.

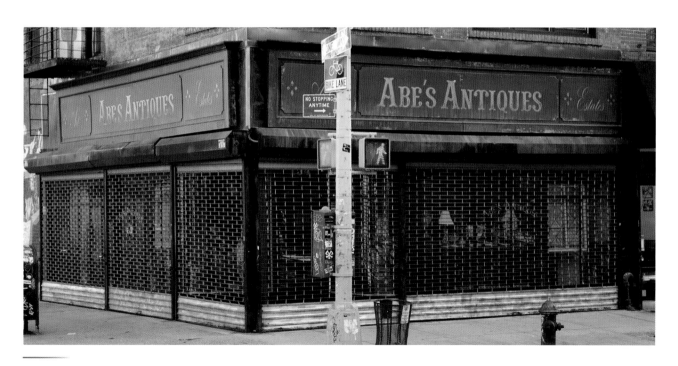

154 Stanton Street

1970S LITTLE ITALY

In late 2017, a few blocks of the Lower East Side were transformed into the Little Italy of the 1970s for director Martin Scorsese's film *The Irishman*. The movie stars Robert De Niro as Frank Sheeran, an alleged hit man involved in the murder of union leader James Hoffa, who disappeared in 1975.

Designers for the film consulted period photographs to create signs that covered the neighborhood's shops and restaurants.

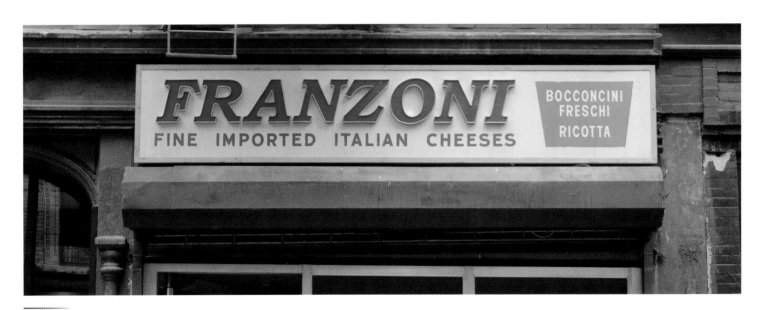

252 Broome Street

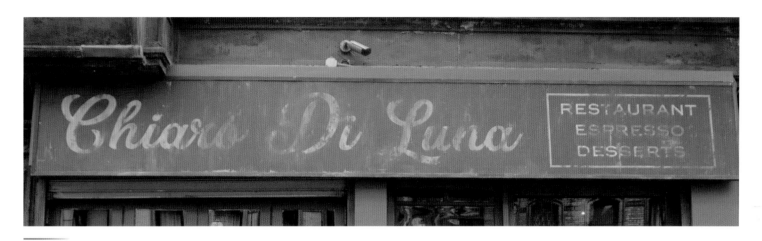

253 Broome Street

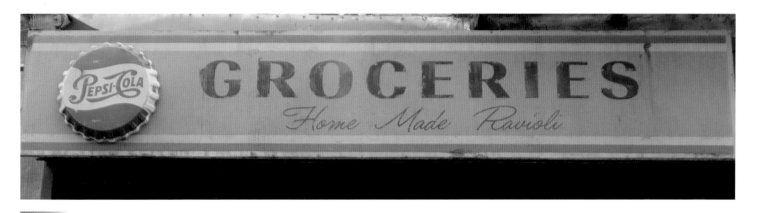

262 Broome Street

CHAPTER SIX:
GOING . . . GOING . . . ALMOST GONE

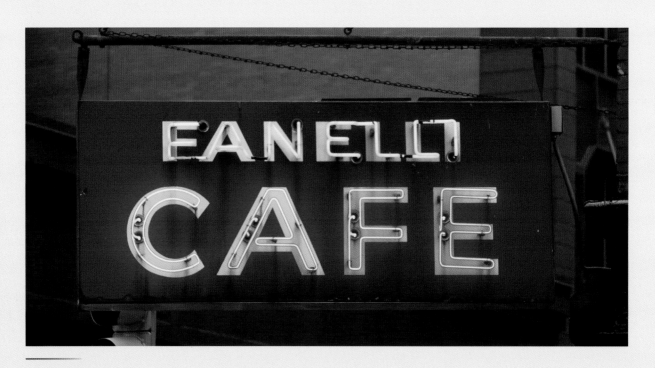

94 Prince Street

BLOCK DRUG STORES

The corner of East Sixth Street and Second Avenue has been home to a drugstore since 1885. The store became part of the now-defunct Block Drug Stores chain in 1942. Its iconic orange-and-pink neon sign was installed in 1945.

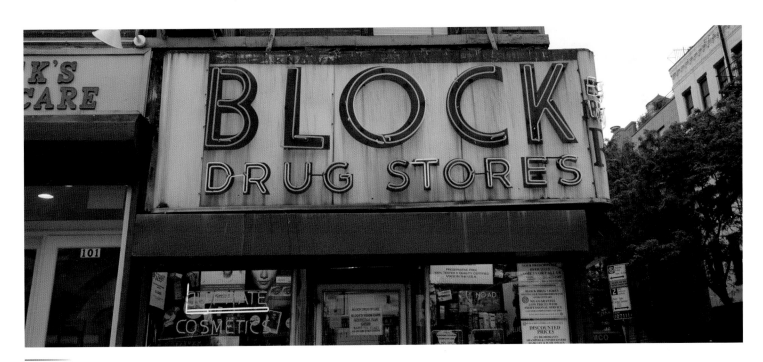

101 Second Avenue

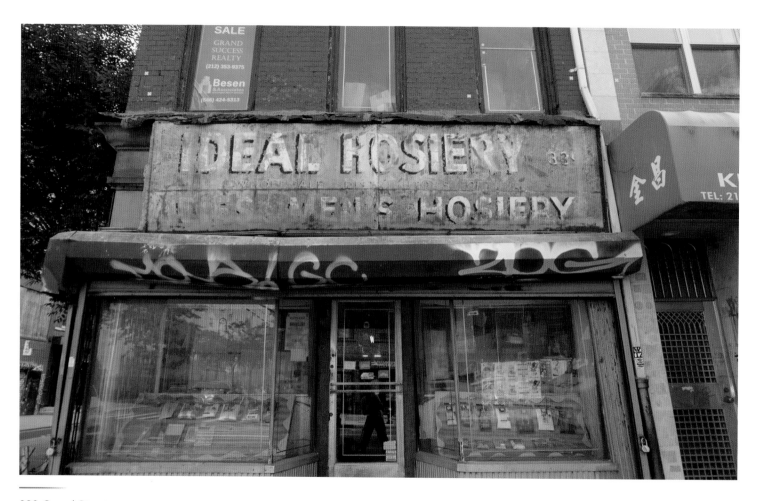

339 Grand Street

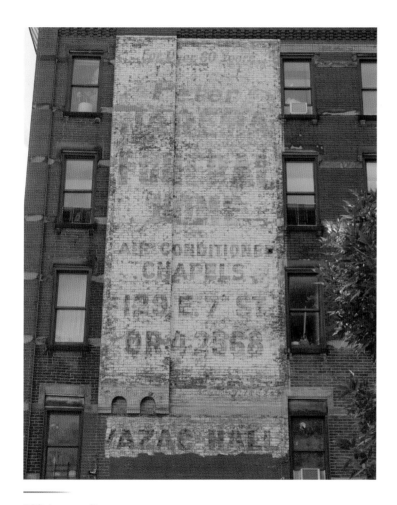

IDEAL HOSIERY

Grand Street was known as Hosiery Row until the late 1980s, when shops that sold socks and stockings at discount prices began to disappear. One of the last holdouts is Ideal Hosiery, a family-owned business since 1950. Ideal is on the ground floor of an 1832 federal-era row house.

PETER JAREMA FUNERAL HOME

The Jarema Funeral Home was founded in 1906 and opened at its current location, 129 East Seventh Street, in 1922. A three-story-high sign for Jarema is painted a few blocks away on the north side of the 7B Horseshoe Bar. The sign's claim of more than sixty years of service would mean it was painted sometime in the late 1960s.

The 7B bar is iconic itself, where scenes from *The Godfather, Part II*, *The Verdict*, and *Crocodile Dundee* were filmed. As Vazac Hall, the site was a catering hall in the 1930s.

57 Grove Street

ARTHUR'S TAVERN

Arthur's Tavern is called the "Home of the Bird" for the regular performances here by jazz great Charlie "Bird" Parker. The Greenwich Village club has featured jazz, blues, and Dixieland jazz since it opened in 1937. Its rusted neon sign appears to be as old as the bar.

ALBANESE MEATS & POULTRY

Vincenzo Albanese emigrated from Sicily and with his wife, Mary, opened Albanese Meats & Poultry in 1923. Butcher shops were once common in Little Italy, but most have now fallen victim to supermarkets.

Director Martin Scorsese grew up on Elizabeth Street and shot a scene at Albanese for his first film, *Who's That Knocking at My Door?*

238 Elizabeth Street

C. O. BIGELOW APOTHECARIES

C. O. Bigelow, founded in 1838 as the Village Apothecary Shop, may be the oldest apothecary in the US. Clarence Otis Bigelow, an employee of founder Dr. Galen Hunter, bought the store in 1880 and moved it to its current location in 1902. Customers included Thomas Edison, Mark Twain, and Eleanor Roosevelt.

Bigelow has two old signs. Its large neon sign dates from the 1930s. A sign on the south side of the building was painted in the mid-1980s. Next to C. O. Bigelow's name is a faded picture, you would imagine, of Bigelow.

"My grandfather bought this business in 1939," said Bigelow president Ian Ginsberg. "My grandfather was never a big fan of Bigelow, so my father wouldn't put his picture on the wall. The picture on the sign is not C. O. Bigelow; it's Martin Van Buren, who was the president in 1838" (Mastropolo 2018).

414 Sixth Avenue

CHERRY LANE THEATRE

The peeling painted sign above the entrance of the Cherry Lane Theatre appears to be from its earliest days. Built as a farm silo in 1817, the building was a tobacco warehouse and box factory before colleagues of playwright Edna St. Vincent Millay created the playhouse in 1924. The Greenwich Village mainstay is New York's oldest continuously running off-Broadway theater.

Playwrights and performers whose careers got an early boost at the Cherry Lane include F. Scott Fitzgerald, Eugene O'Neill, David Mamet, Gene Hackman, and James Earl Jones.

38 Commerce Street

NOM WAH TEA PARLOR

Doyers Street in Chinatown bends at an almost 90-degree angle. In the early 1900s, the street was known as the "Bloody Angle" because of violent gang battles on the block. Nom Wah opened in 1920 at 15 Doyers Street but in 1968 lost its lease and moved next door to its current location. Today, pork buns, assorted dumplings, and shrimp rice rolls are among its bestsellers.

Its sign features Chinese characters across its base. "The characters, read from right to left, say 'Nom Wah Tea Parlor, Nom Wah Pastry Making Company,'" said manager Vincent Tang. "Nom Wah used to sell pastries like mooncakes and buns. The sign is a representation of what this restaurant used to sell" (Mastropolo 2018).

13 Doyers Street

BIBLIOGRAPHY

Ackerson, Elizabeth, Shayne Leslie Figuerora, and Jennifer Joyce. "Walking East Third Street: The Bowery Branch YMCA." *Greenwich Village Society for Historic Preservation* (blog), December 24, 2012. http://gvshp.org.

Amateau, Albert. "Ear Inn Has Colorful History and Uncertain Future." *The Villager*, Aug. 27–Sept. 2, 2003. http://thevillager.com.

Arthur's Tavern. "History," http://www.arthurstavernnyc.com.

Asbury, Herbert. *The Gangs of New York: An Informal History of the New York Underworld* (1927). New York: Hippocrene, 1989.

Baker Brush advertisement. *Popular Science*, September 1953. https://books.google.com.

Batchelor, LaRon. "Sam's Knitwear: 'The Whole Lower East Side Is Changing. People Are Changing.'" *My Small Story* (blog), July 27, 2011. https://mysmallstory.wordpress.com.

Berger, Joseph. "Painted Signs, Relics of a Bygone New York, Become Even More Rare." *New York Times*, November 5, 2005. www.nytimes.com.

Besonen, Julie. "Bye-Bye Barley Soup: Legendary Dairy Restaurant Ratner's Is Answering to a Higher Commercial Authority." *New York Daily News*, April 23, 2000. www.nydailynews.com.

Brewer, Daryln. "Canvas for Awnings, Aprons, Covers." *New York Times*, February 15, 1990.

Buckholtz, Sarah. "Walldogs—the Artists behind Ghost Signs." *Antique Archaeology* (blog), last modified May 11, 2017. www.antiquearchaeology.com.

C. O. Bigelow Apothecaries. "Our History." www.bigelow-chemists.com.

Cherry Lane Theatre. "History." www.cherrylanetheatre.org.

Cohen's Fashion Optical. "About Us." www.cohensfashionoptical.coms.

"The Colborne Sold: 'Village' Hotel Is Renamed—Modernization Planned." *New York Times*, April 13, 1960.

Confino, Terence. "Classic Red Sauce Restaurant Is Closed after Huge Rent Hike." *The Villager*, January 19, 2012. http://thevillager.com.

Crow, Kelly. "City Lore: Sailors' Quarters, Once 25 Cents." *New York Times*, April 22, 2001. www.nytimes.com.

Davis, Amanda. "My Favorite Things: East Eleventh Street Baths." *Off the Grid* (blog), March 5, 2012. http://gvshp.org.

Ear Inn. "Our Story." www.earinn.com.

Elie. "The Colorful History of 49 Market Street." *Bowery Boogie* (blog), March 24, 2010. www.boweryboogie.com.

———. "Katz's Deli Ghost Signage Uncovered during Ben Shaoul Demolition." *Bowery Boogie* (blog), last modified February 19, 2016. www.boweryboogie.com.

Feirstein, Sanna. *Naming New York: Manhattan Places and How They Got Their Names*. New York: New York University Press, 2001.

Fertitta, Naomi. *New York: The Big City and Its Little Neighborhoods*. New York: Universe, 2009.

Forgang, Isabel. "Fabric Store Leaves Lower East Side and Makes a Bolt for the Flatiron Interior Redesign." *New York Daily News*, March 14, 1999. www.nydailynews.com.

"Fourteen Die of Heat, Dozens Are Prostrated." *New York Times*, July 1, 1906.

Galtman, Ira (director, Corporate Archives, American Express), in discussion with the author, May 14, 2018.

Ginsberg, Ian (president, C. O. Bigelow Apothecaries), in discussion with the author, May 7, 2018.

Gold Medal Flour. "Our Timeless Heritage." www.goldmedalflour.com.

Gray, Christopher. "Streetscapes / the Northern Dispensary: Plan to House Homeless with AIDS Stirs a Protest." *New York Times*, October 10, 1993. www.nytimes.com.

———. "Streetscapes / Rex Cole's General Electric Appliance Buildings, Designed by Raymond Hood in the 1930's: Master Architect's Showy Refrigerator Showrooms." *New York Times*, August 17, 2003. www.nytimes.com.

Grutchfield, Walter. "Parodi Factory." *Walter Grutchfield* (blog). www.waltergrutchfield.net.

———. "Peter Jarema Funeral Home." *Walter Grutchfield* (blog). www.waltergrutchfield.net.

———. "Ragú Spaghetti Sauce." *14 to 42* (blog). www.14to42.net.

Harary, Albert (vice president, Martin Albert Interiors), in discussion with the author, Mar. 19, 2018.

Harris, Elizabeth A. "At High-Priced Corner, a Building Forlorn." *New York Times*, March 25, 2013. www.nytimes.com.

"Hebrew Actors' Union." YIVO Institute for Jewish Research. www.yivoarchives.org.

Hevesi, Dennis. "Spencer B. Witty, 92, Men's Clothier to a Discriminating Clientele, Dies." *New York Times*, June 5, 2006. www.nytimes.com.

Hill, Daniel Delis. *Advertising to the American Woman, 1900–1999*. Columbus: Ohio State University Press, 2002.

Hughes, C. J. "From the Outside, They Still Look Like Banks." *New York Times*, February 6, 2005. www.nytimes.com.

J&R Music World. "About J&R." https://web.archive.org.

Jensen, Ryan. "Delancey: Deal or No Deal?" *Notes from the Tenement* (blog), Tenement Museum, November 17, 2015. https://tenement.org.

Katz's Delicatessen. "Our Story." www.katzsdelicatessen.com.

Kim, Betsy. "Tiles Underfoot Recall Owner Who Put His Foot Down." *The Villager*, August 4–10, 2011. http://thevillager.com.

Kopper's Chocolate. "About Us." https://kopperschocolate.com.

Landmarks Preservation Commission. "Two White Street House." July 19, 1966. www.neighborhoodpreservationcenter.org.

Lueck, Thomas J., and Colin Moynihan. "Roof Collapses at Historic Lower Manhattan Synagogue." *New York Times*, January 23, 2006. www.nytimes.com.

"The Maid." *Seinfeld*, NBC, April 30, 1998.

M. Katz & Sons. "About Us." http://katzfurniture.com.

Mastropolo, Frank. "Even More Great Ghost Signs of the East Village and LES." *Bedford+Bowery* (blog), July 13, 2015. http://bedfordandbowery.com.

———. "More Great Ghost Signs of the East Village and LES." *Bedford+Bowery* (blog), March 29, 2018. http://bedfordandbowery.com.

———. "Scorsese Transforms the LES into '70s Little Italy, for *The Irishman*." *Bedford+Bowery* (blog). http://bedfordandbowery.com.

———. "Still More Great Ghost Signs of the East Village and LES." *Bedford+Bowery* (blog), March 28, 2016. http://bedfordandbowery.com.

———. "'This Is My Living Room': After 110 Years, De Robertis Caffé Will Close Dec. 5." *Bedford+Bowery* (blog), November 24, 2014. http://bedfordandbowery.com.

———. "Top 10 Ghost Signs of the East Village and LES." *Bedford+Bowery* (blog), January 13, 2015. http://bedfordandbowery.com.

Mattison, Ben. "Charlie Parker Saxophone Draws Top Bid at Jazz Auction." *Playbill*, February 22, 2005. www.playbill.com.

Meier & Oelhaf advertisement. *Master, Mate, and Pilot*, April 1909. https://books.google.com.

Miller, Tom. "The Alabama House—Nos. 219–221 Bowery." *Daytonian in Manhattan* (blog), June 24, 2016. https://daytoninmanhattan.blogspot.com.

———. "Independent Kletzker Brotherly Aid Society—No. 5 Ludlow Street." *Daytonian in Manhattan* (blog), July 15, 2015. http://daytoninmanhattan.blogspot.com.

———. "No. 50 West 10th Street—a Carriage House with Broadway History." *Daytonian in Manhattan* (blog), June 14, 2011. http://daytoninmanhattan.blogspot.com.

"'Monk' Eastman, Gang Leader and War Hero, Slain by Rival Gunmen." *New York Tribune*, December 27, 1920. https://chroniclingamerica.loc.gov.

Moss, Jeremiah. *Vanishing New York: How a Great City Lost Its Soul*. New York: Dey St., 2017.

Myers, Alice. "Chinese Laundries." *Immigration to the United States* (blog). http://immigrationtounitedstates.org.

Nemy, Enid. "The Great Boot Boom of '70: Expense, It Seems, Is No Object." *New York Times*, September 29, 1970. www.nytimes.com.

Nin, Anaïs. *The Journals of Anaïs Nin*. Vol. 4, *1944–1947*. Edited by Gunter Stuhlmann. New York: Mariner Books, 1972.

Patronite, Rob, and Robin Raisfeld. "History in the Baking." *New York*, August 24, 2009. http://nymag.com.

Ragú. "Our Story." www.ragu.com.

Riis, Jacob A. *How the Other Half Lives: Studies among the Tenements of New York* (1890). Eastford, CT: Martino Fine Books, 2015.

Rinaldi, Thomas E. "Loft's on Nassau." *New York Neon* (blog), October 2, 2016. http://nyneon.blogspot.com.

"Samuel Slotkin of Hygrade Dies; Founder of Meat Company and Leader in Packaging." *New York Times*, October 31, 1965.

Schulz, Dana. "Kleindeutschland: The History of the East Village's Little Germany." *6sqft* (blog), October 2, 2014. https://www.6sqft.com.

Sears, Jocelyn. "Fourteen Vintage Ads Featuring Ronald Reagan." *Mental Floss* (blog), February 6, 2017. http://mentalfloss.com.

Shockley, Jay. "Greenwich Village Historic District Extension Designation Report." New York City Landmarks Preservation Commission, May 2, 2006. www.gvshp.org.

Shulman School advertisement. *Jewish Morning Journal*, May 30, 1915, *Forward* Archive. https://forward.com.

Silverberg, Steve (president, Spanjer Sign Corp.), in discussion with the author, April 27, 2018.

Smith, Andrew F. *New York: A Food Biography*. Lanham, Md.: AltaMira, 2013.

Stix, Lawrence C., Jr. "Short Narrative History of S. Oppenheimer & Company: Its Rise to Eminence—Its Fall From Grace." https://jacullman.files.wordpress.com.

Stover, Andrea. "The Day after Christmas, When Sharpshooters Marched Up the Bowery." *Bedford+Bowery* (blog), December 26, 2013. http://bedfordandbowery.com.

Tang, Vincent (manager, Nom Wah Tea Parlor), in discussion with the author, June 16, 2018.

Tcholakian, Danielle. "Avignone Chemists, Village Staple since 1929, Closing after Rent Hike." *DNAInfo* (blog), January 21, 2015. https://www.dnainfo.com.

"Tea Time: The Story of the Nom Wah Tea Parlor." *Notes From the Tenement* (blog), Tenement Museum, August 19, 2015. https://tenement.org.

Tree-Mark Shoes advertisement. *Brooklyn Daily Eagle*, January 27, 1939. https://www.newspapers.com.

Vail, Ken. *Bird's Diary: The Life of Charlie Parker, 1945–1955*. Chessington, UK: Castle Communications, 1996.

Wallace, Elizabeth Victoria. *Hidden History of Denver*. Mt. Pleasant, S.C.: The History Press, 2011.

"When Horses Ruled NYC: A Series on Historic Stable/Carriage Houses: 129 Charles Street." *WestView News*, May 1, 2015. http://westviewnews.org.

Witty, Nicole. Comment on Mastropolo, "More Great Ghost Signs."

Woodruff, Sheryl. "Block Drug Store: 2013 Village Award Winner." *Off the Grid* (blog), June 3, 2013. http://gvshp.org.

Young, Greg, and Tom Meyers. *The Bowery Boys Adventures in Old New York*. Berkeley, CA: Ulysses, 2016.

INDEX